BIRDS OF PARADISE

a therapeutic coloring
book for adults

LORNA SCOBIE

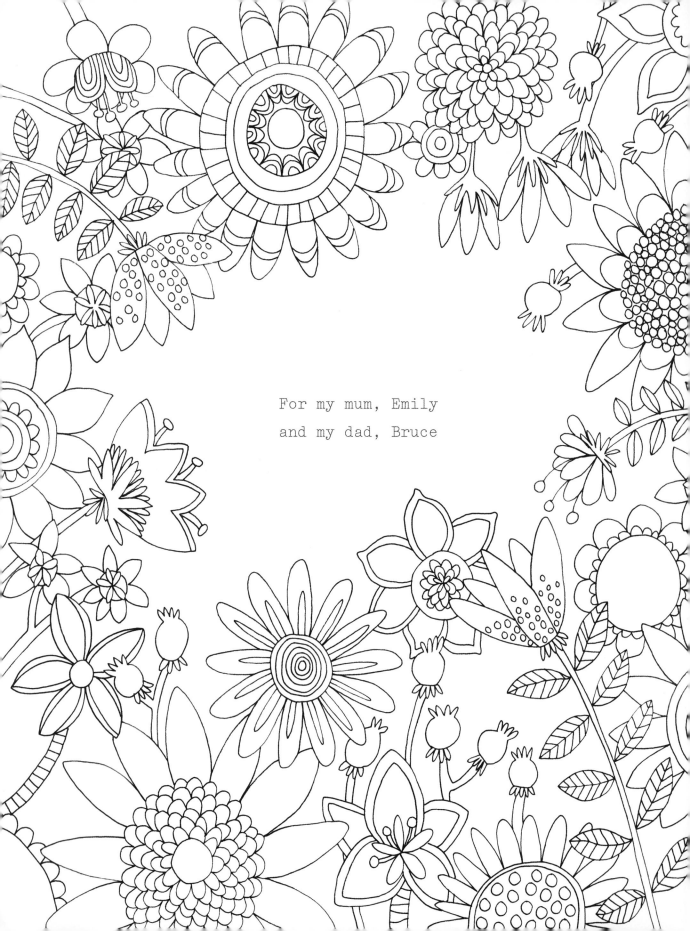

For my mum, Emily
and my dad, Bruce

BIRDS OF PARADISE

a therapeutic coloring
book for adults

LORNA SCOBIE

Hardie Grant

BOOKS

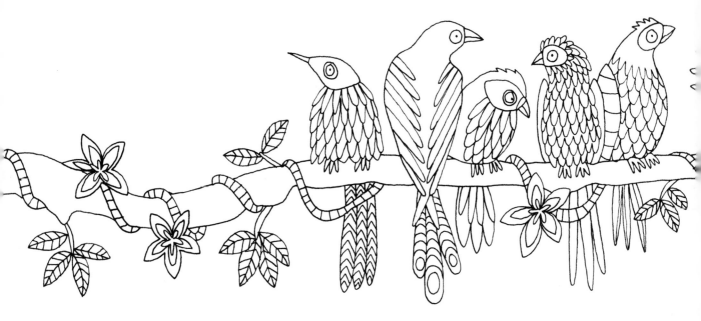

Welcome to *Birds of Paradise*: a place where you can switch-off and slow down into the meditative world of coloring-in.

We all seem to have such busy lives these days, rushing about at work, at home, running various errands, leaving very little time to re-energise, to stimulate our minds, and simply reward ourselves with a feeling of happiness. Coloring-in is an easy way to focus your mind solely on being creative; it is the perfect way to relax your thoughts and use your imagination to produce something artistic. But most importantly, it is time spent on you for yourself, rather than anyone else.

I love birds. For me, they are the perfect representation of tranquility and beauty in the natural world. Tropical birds and birds of paradise in particular, have colorful and distinctive plumage, which gives each bird its own unique personality. This makes them the perfect subjects for my drawings as their intricate feather patterns and vibrant hues always inspire me to reach for my sketchbook. From the shimmering tail of the peacock to the magnificent headdress of the Victoria crowned pigeon, the world of birds offers a fantastic variety of colors and textures.

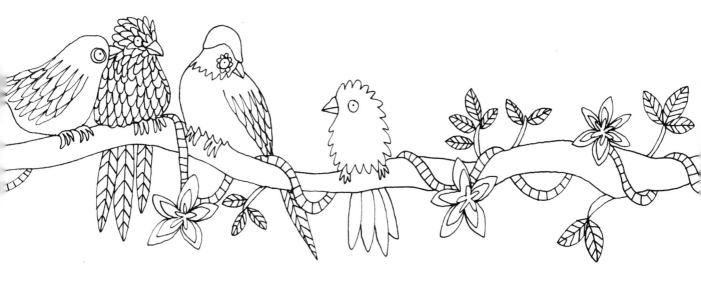

Anyone of any age or artistic ability can take a few minutes each day to find stillness and peace by coloring-in. Hardly any preparation is needed for you to wind down and begin to relax — just choose your coloring pencils, open a page, and start coloring.

In this book, I've managed to restrain myself from grabbing my coloring pencils and left the drawings for you to color in!

Focus on the detailed, individual sections of feathers and wings when you'd like to spend a longer length of time on a spread; or color larger areas in one go, choosing your own boundaries within the image. Each page can be as intricate or bold as you like — the choice is yours.

Alongside some of the drawings, I have included facts about the birds so that you can learn as you color. You will quickly see the illustrations become your own unique creation as you fill them with color.

So think of this book as a beautifully fun, interactive and personal spa treatment for your mind. It's your way of reconnecting with yourself, to simply escape and let your imagination soar into the wonderful world of birds…

Happy coloring!

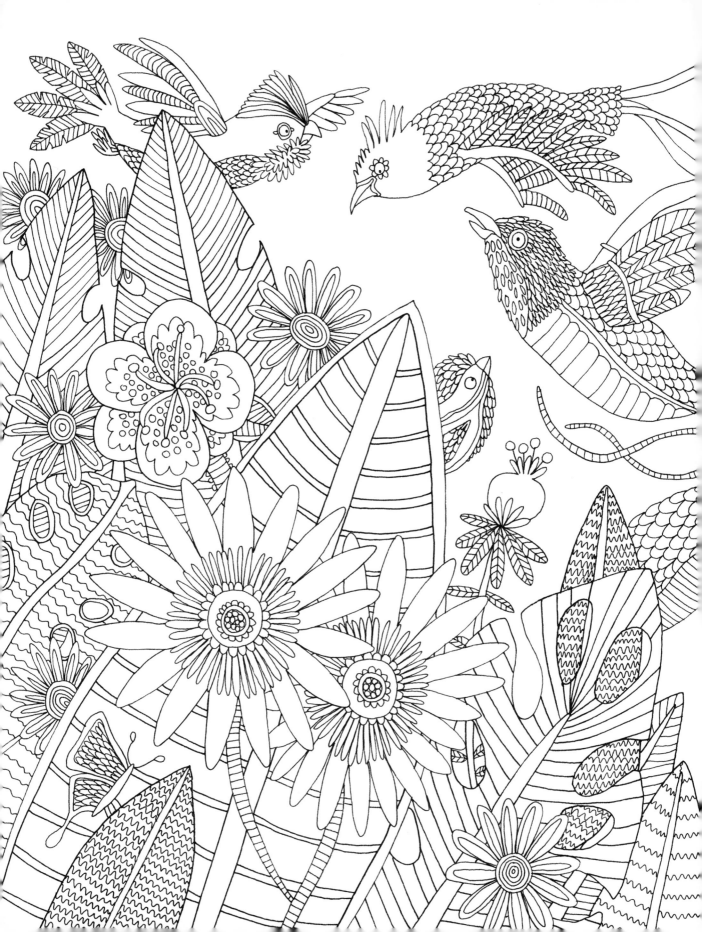

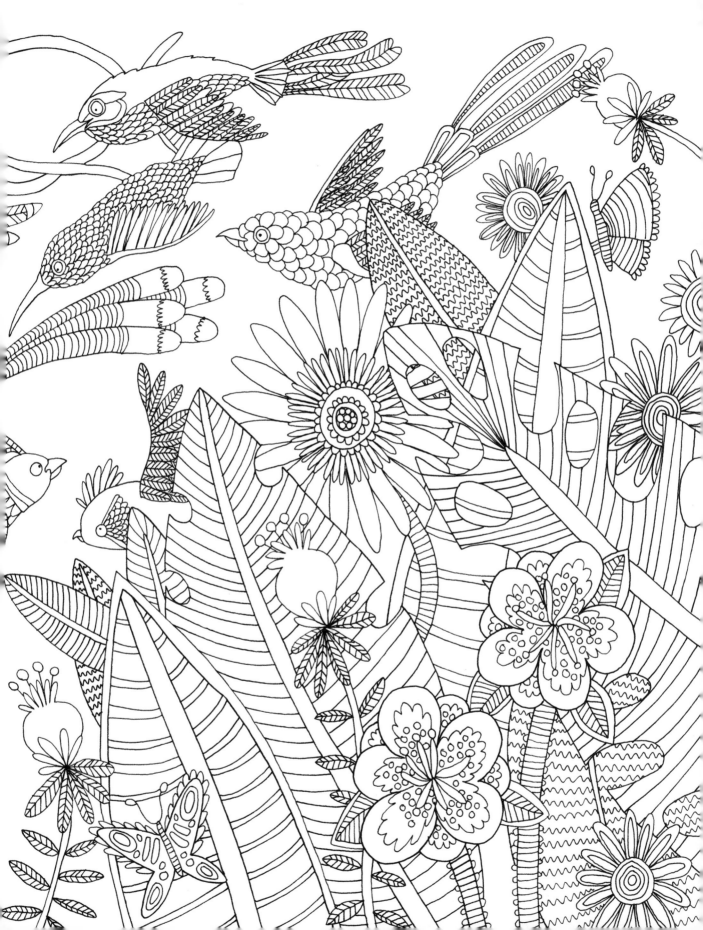

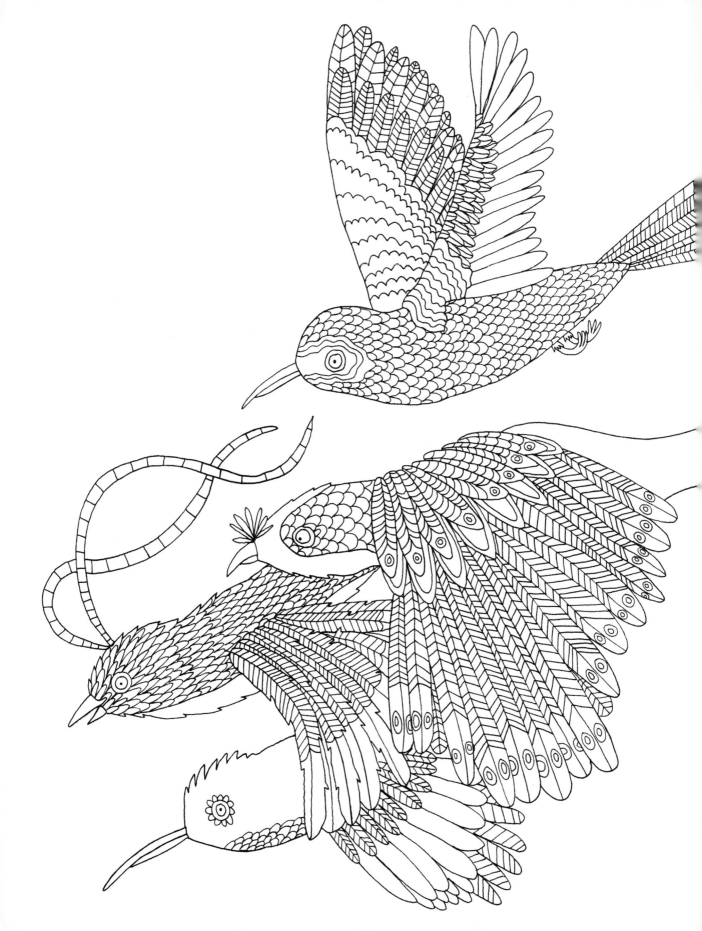

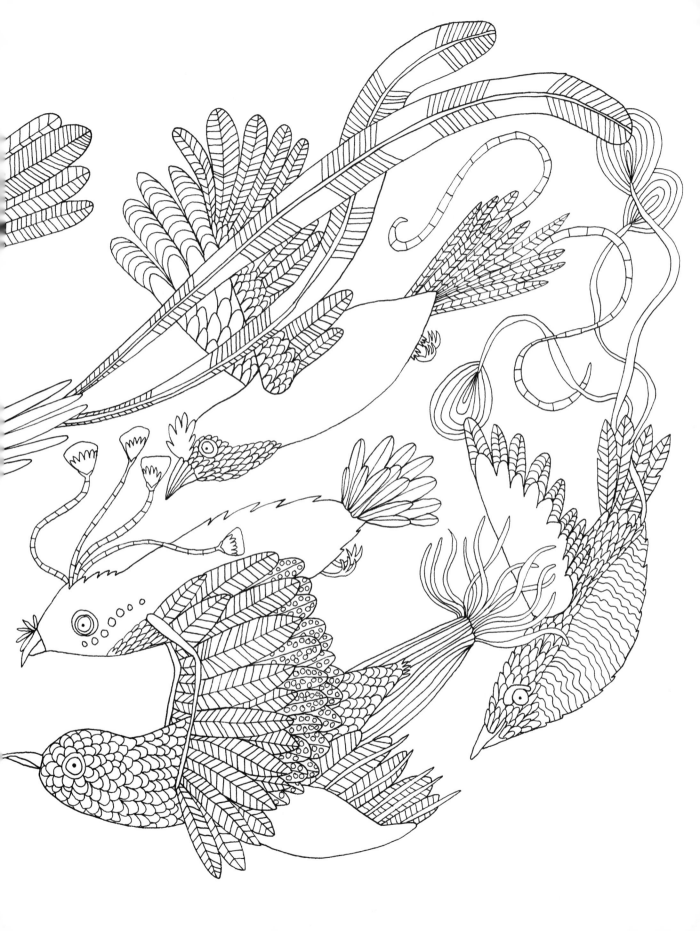

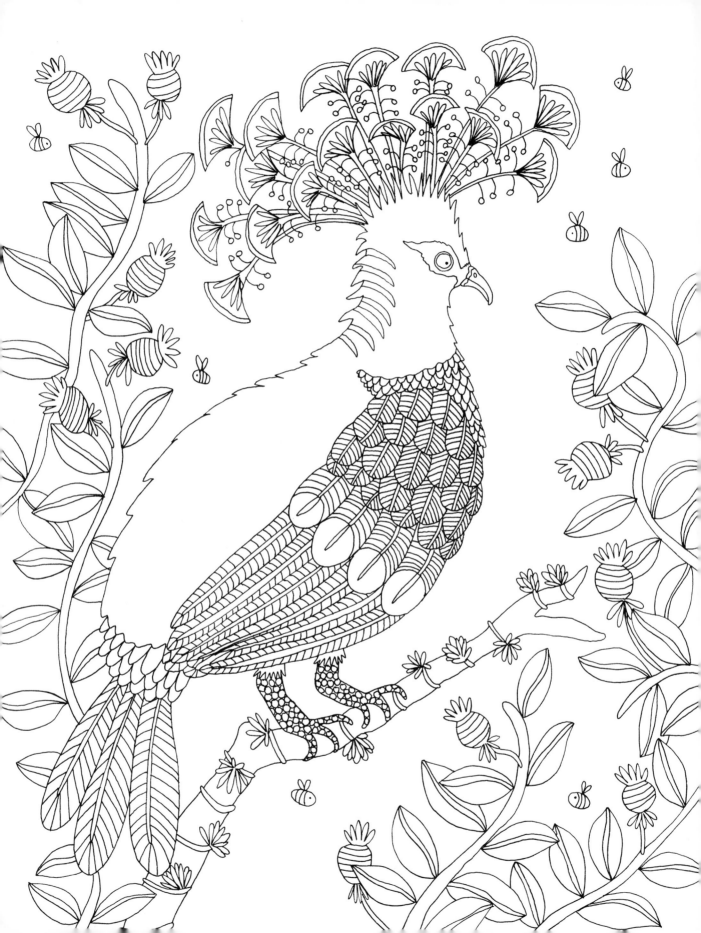

VICTORIA CROWNED PIGEON

Victoria crowned pigeons
are monogamous and tend
to mate for life.

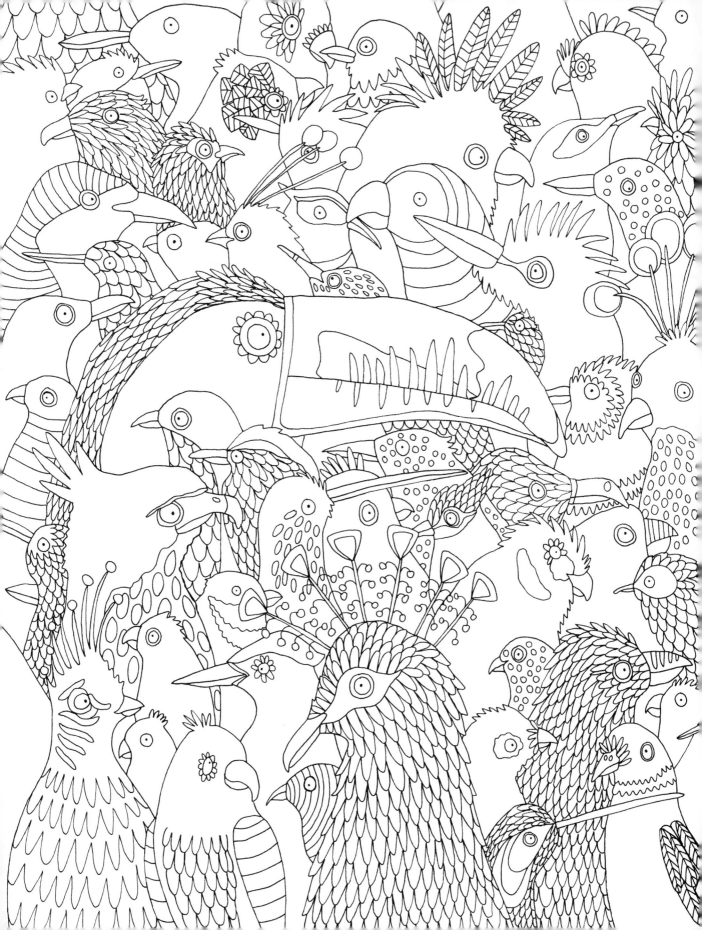

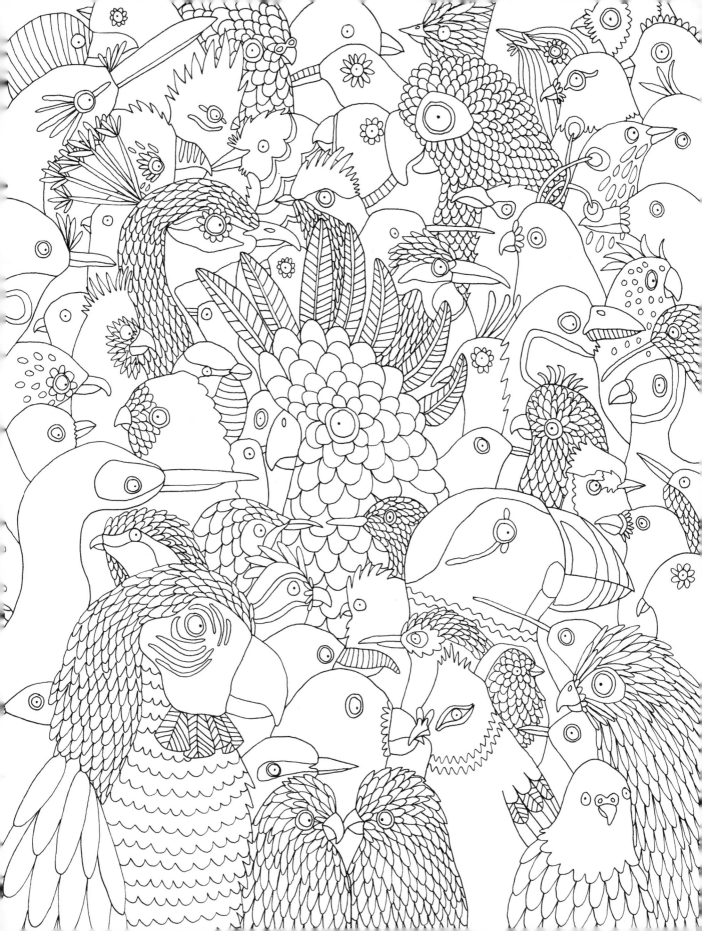

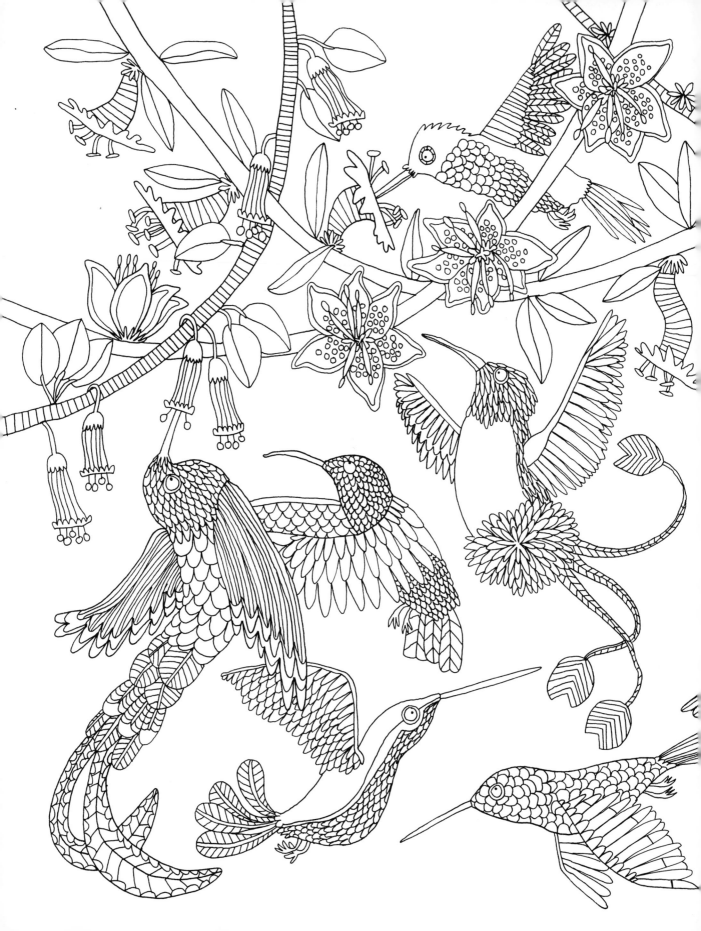

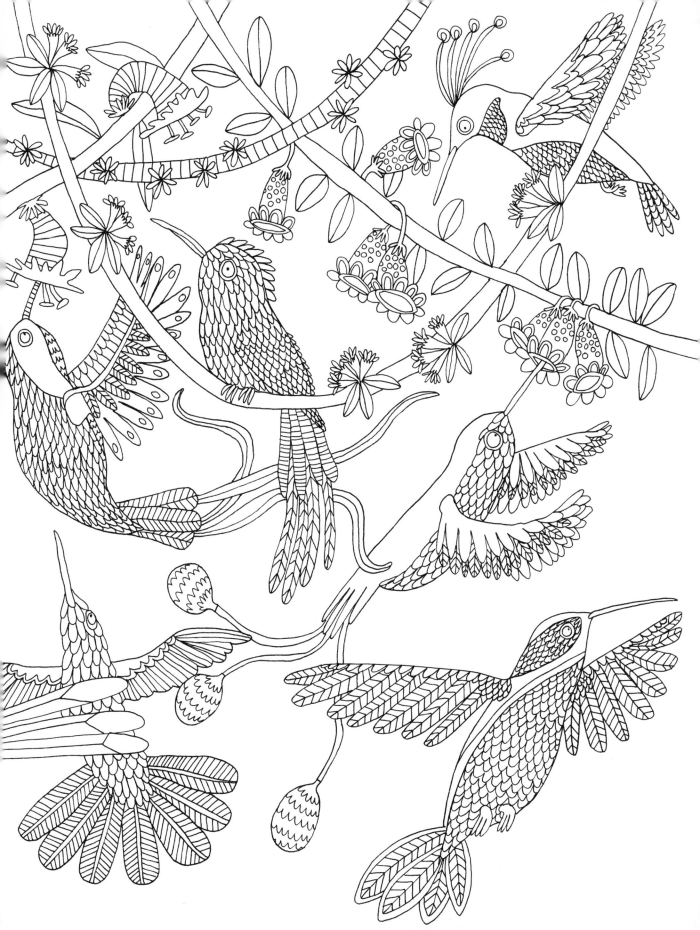

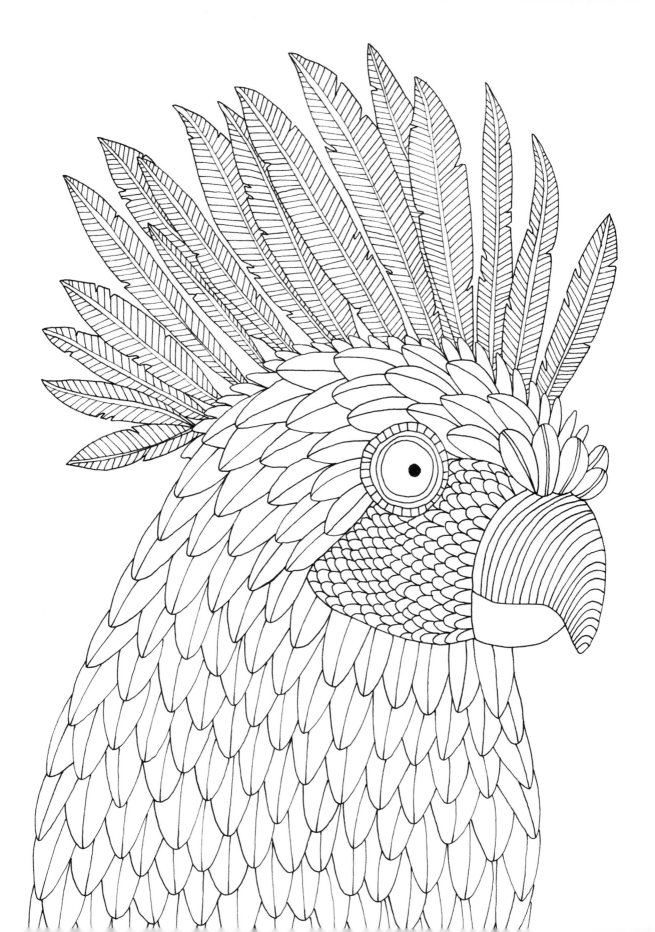

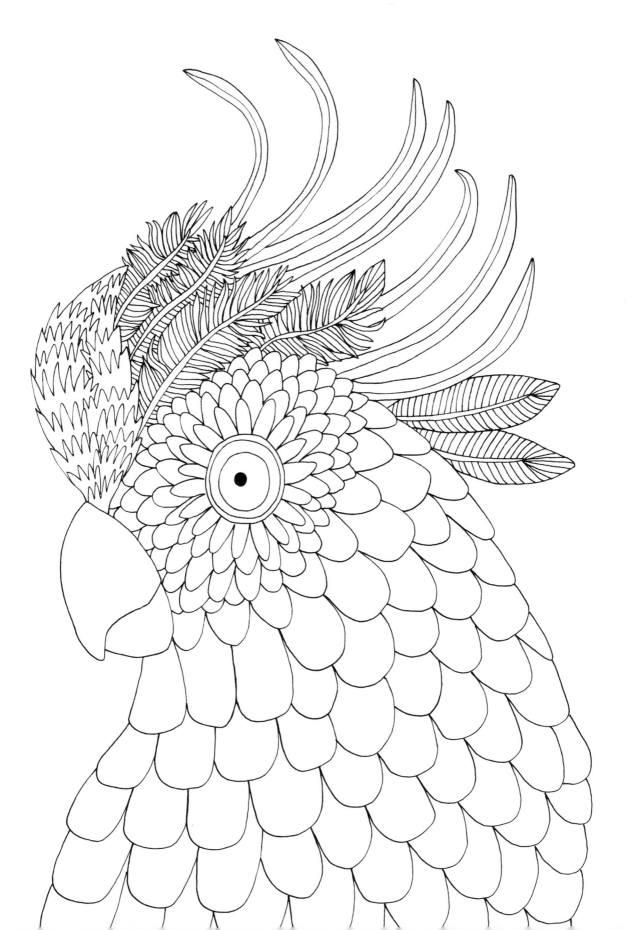

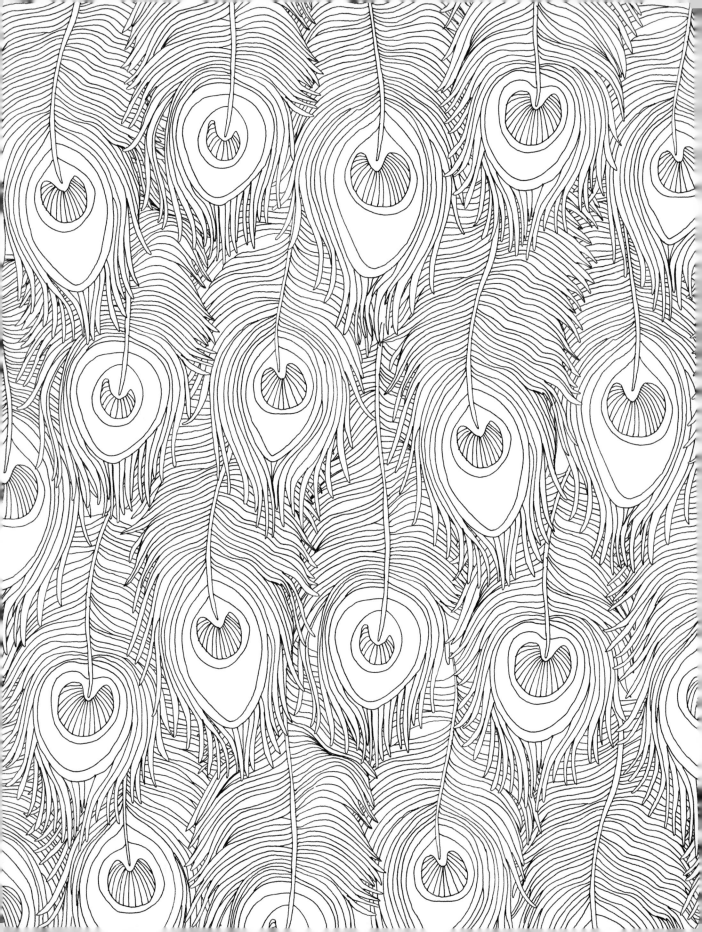

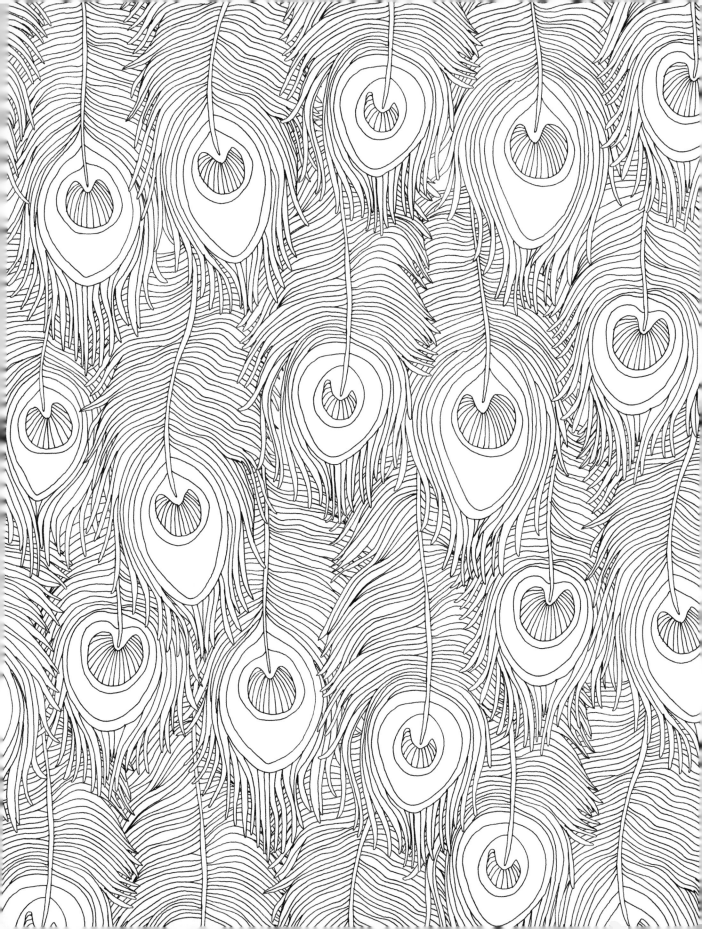

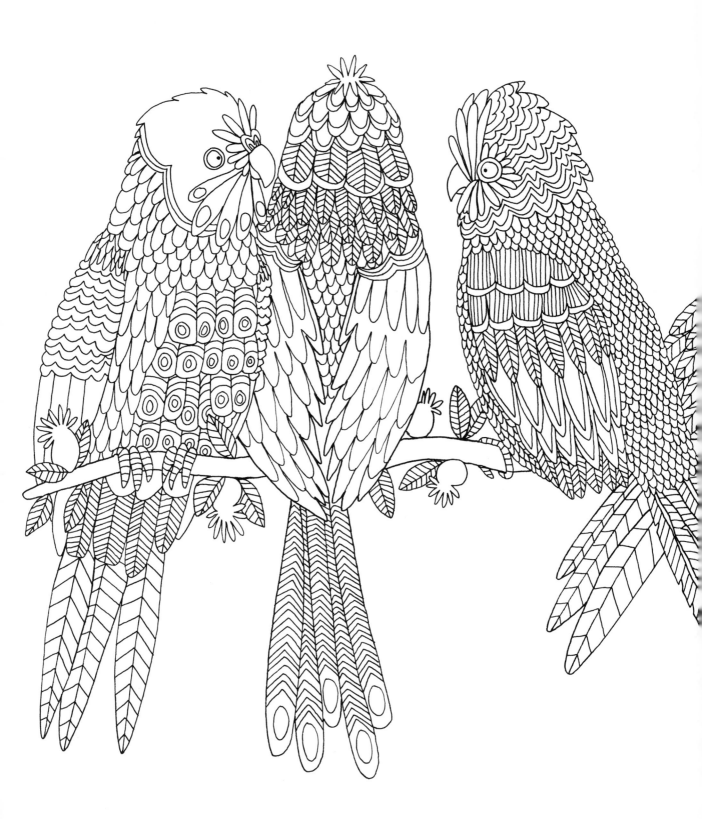

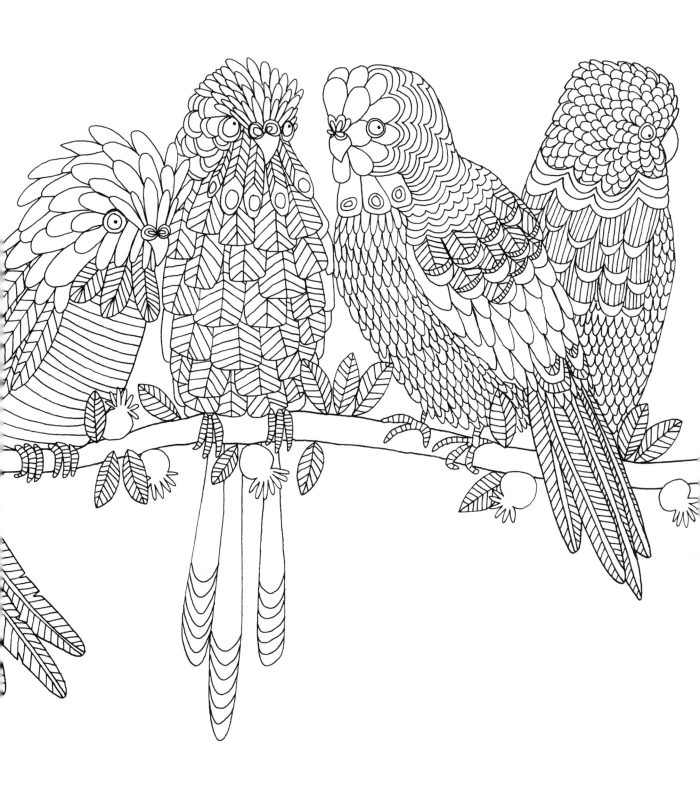

PEACOCK

Peacock feathers are covered
in microscopic crystal-like
structures, which create their
shimmering, vibrant colors.

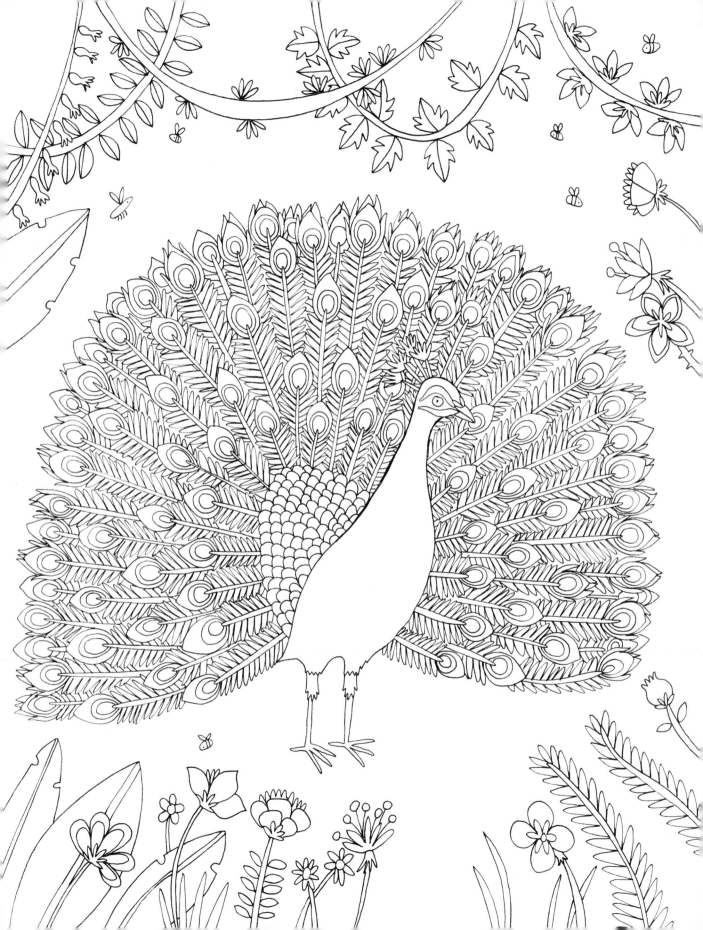

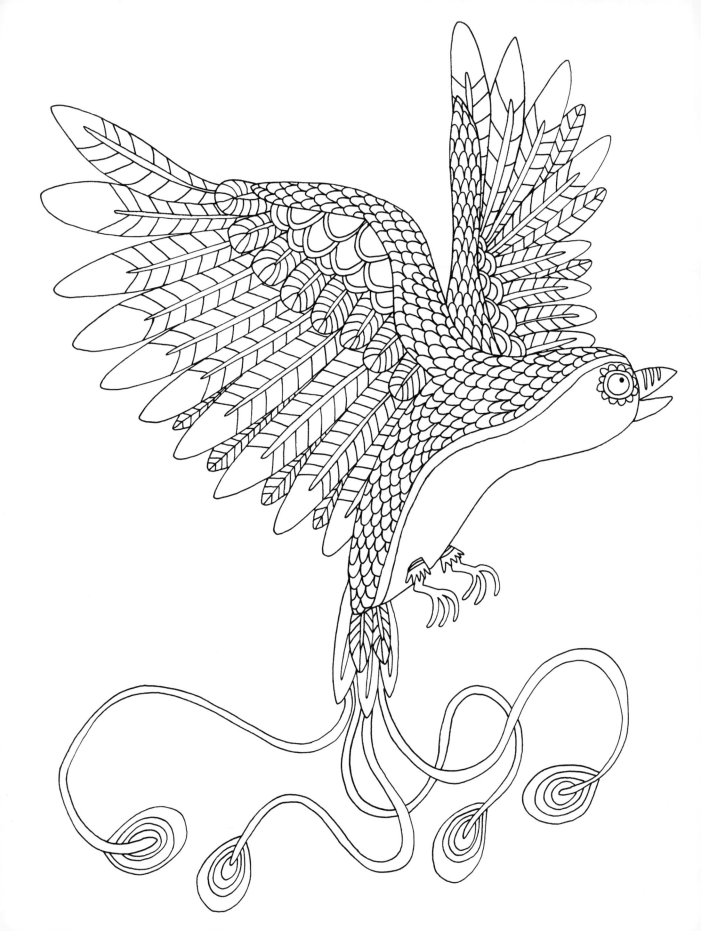

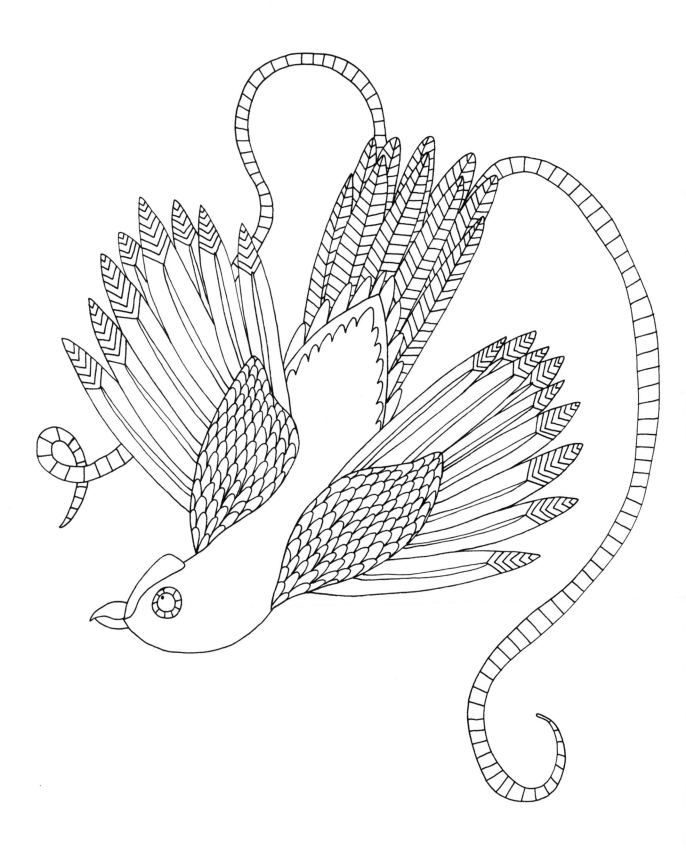

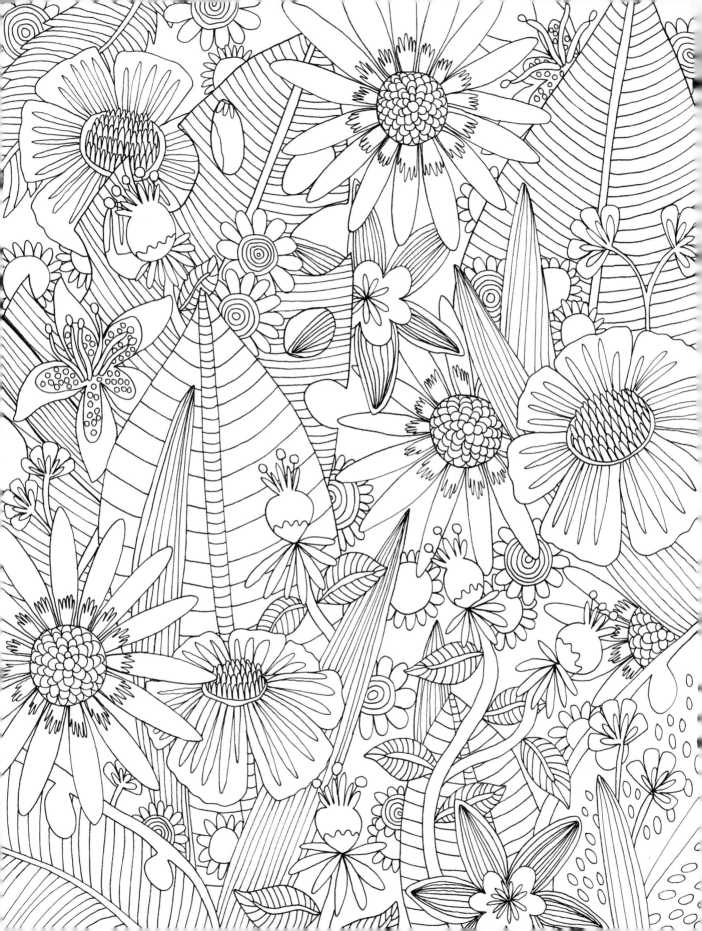

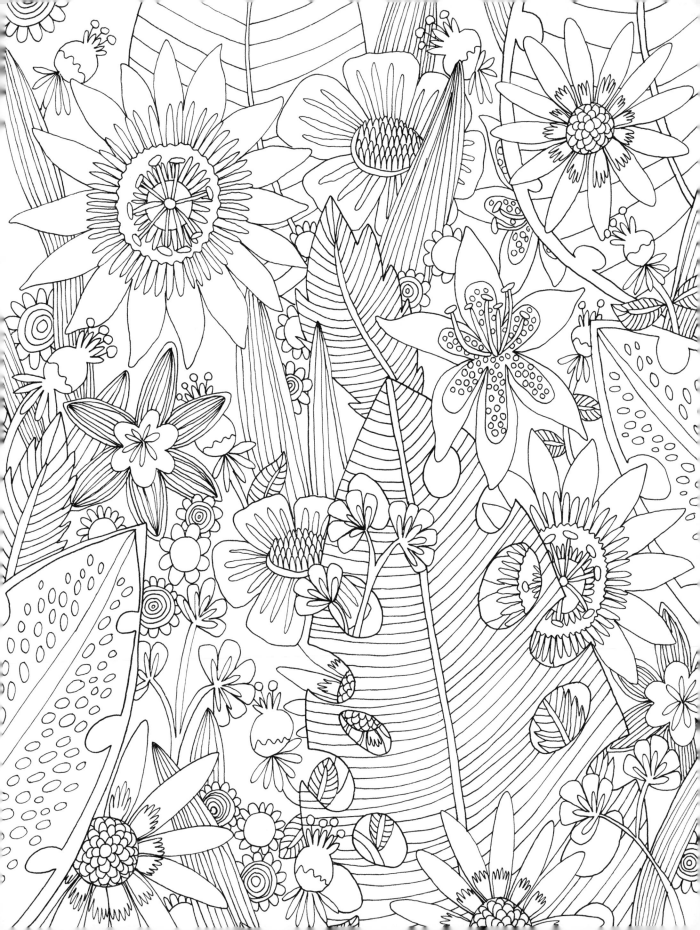

BLUE BIRD OF PARADISE

The males perform elaborate
courtship rituals that can
last for hours, hanging upside
down from branches and
spreading their plumage
in an eye-catching fan,
swaying from side to side.

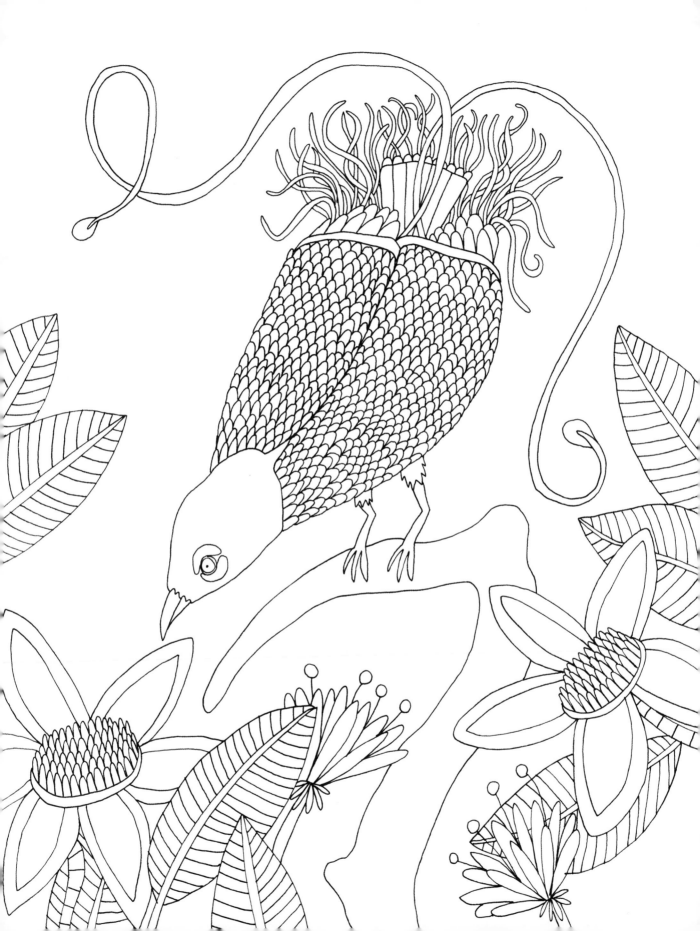

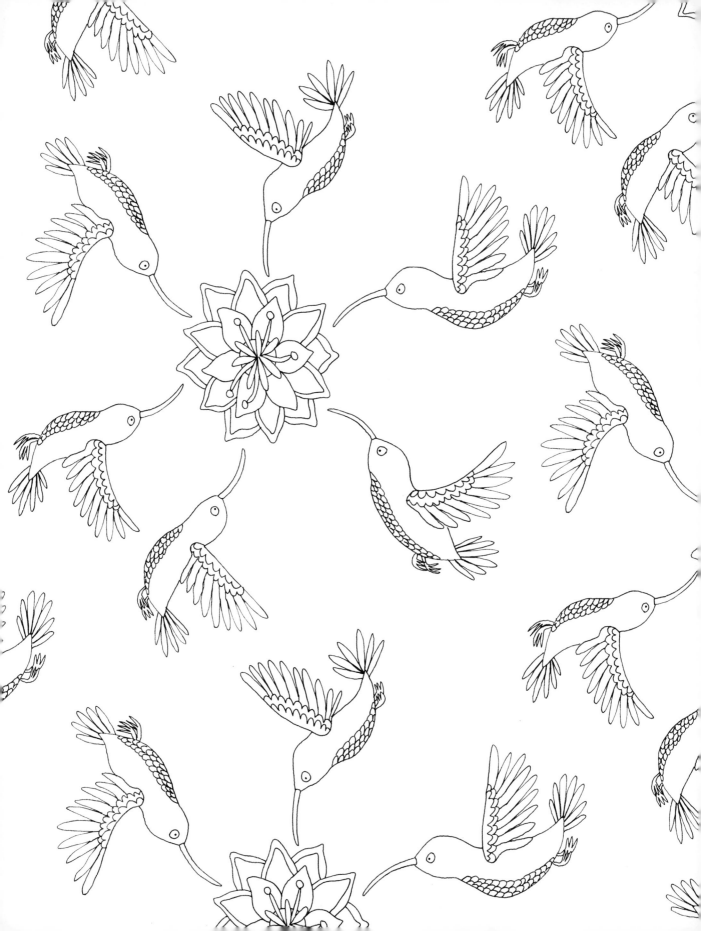

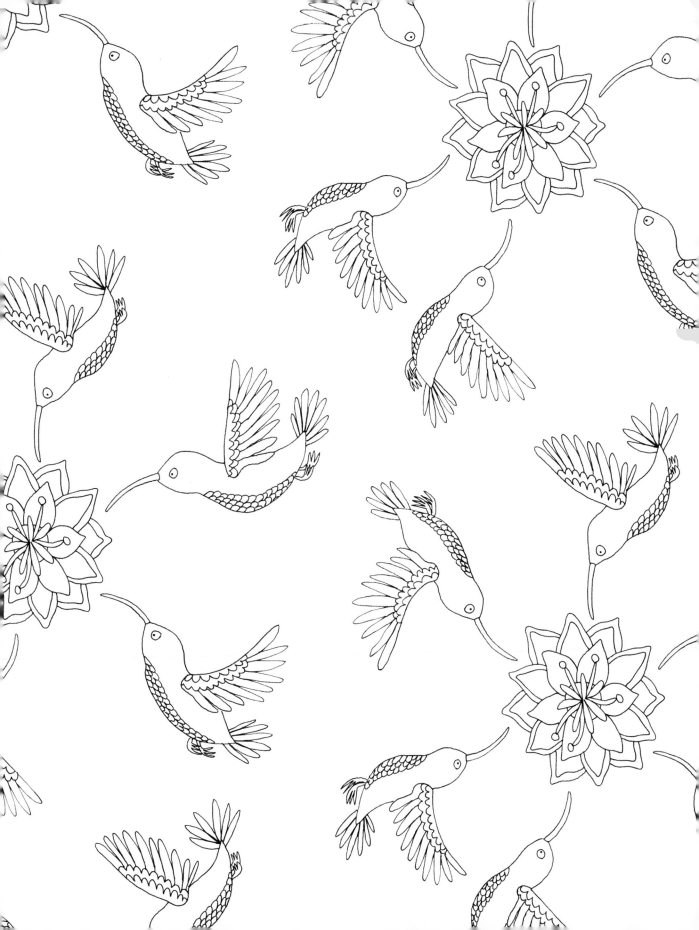

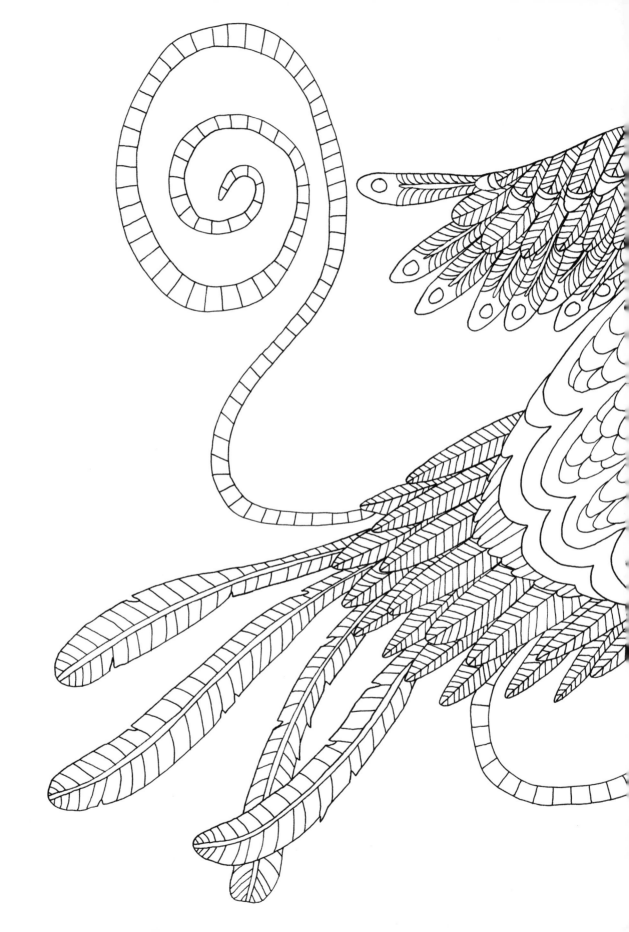

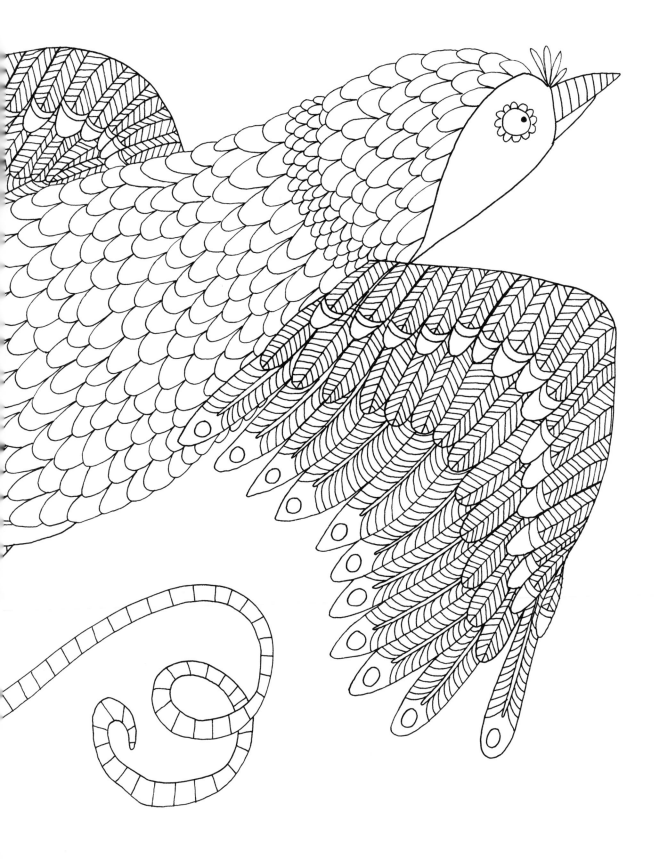

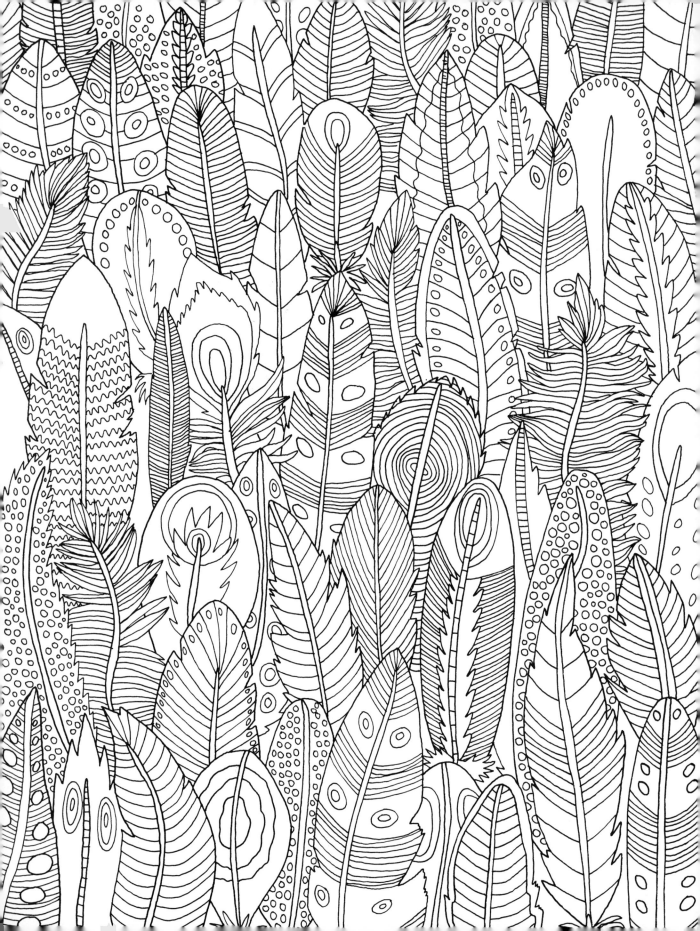

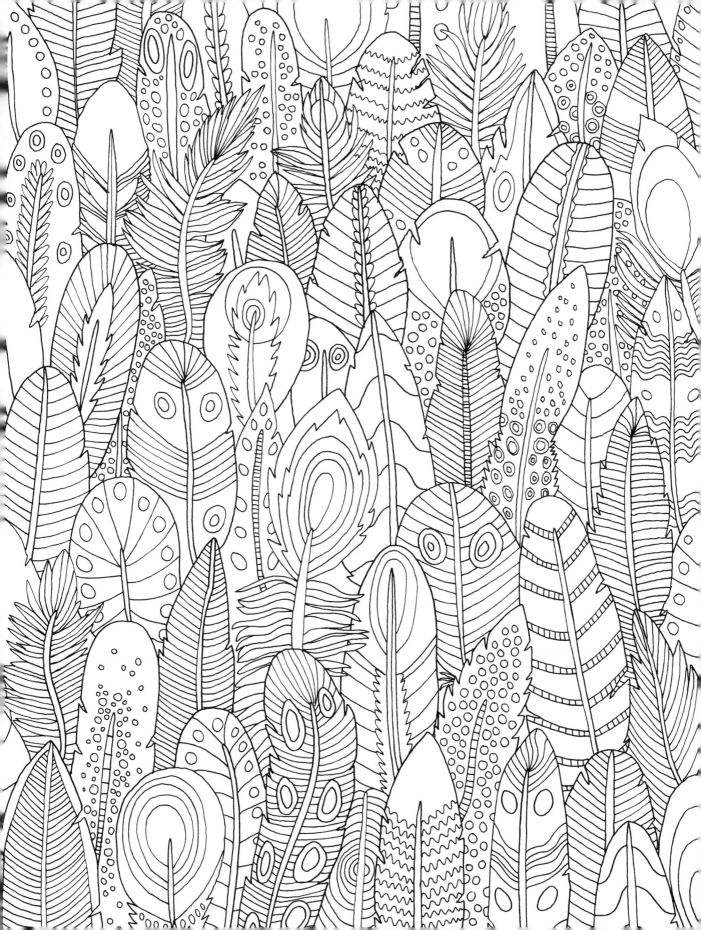

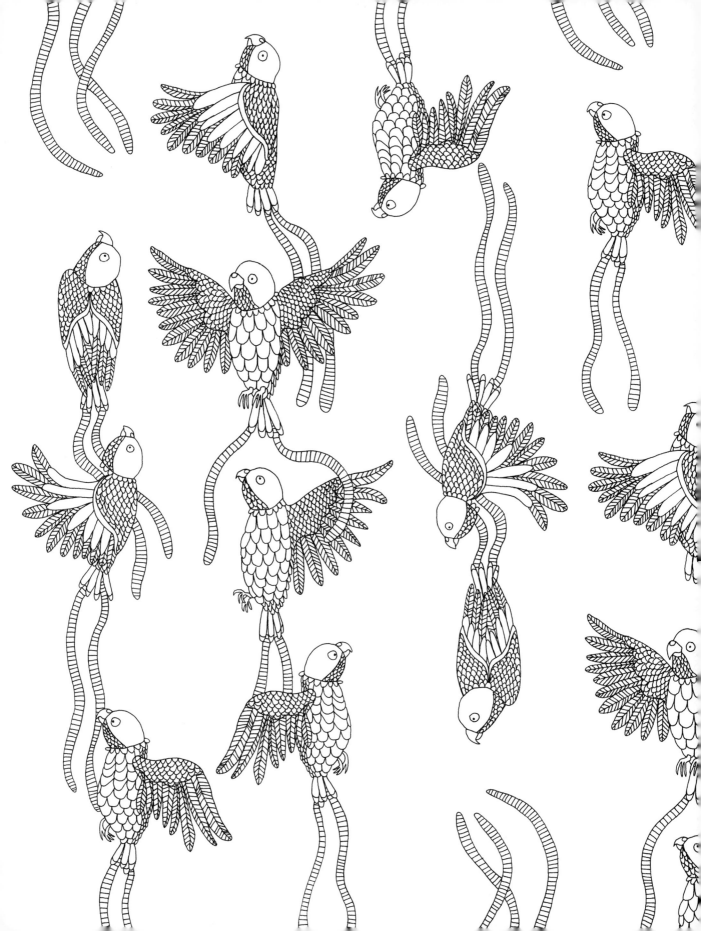

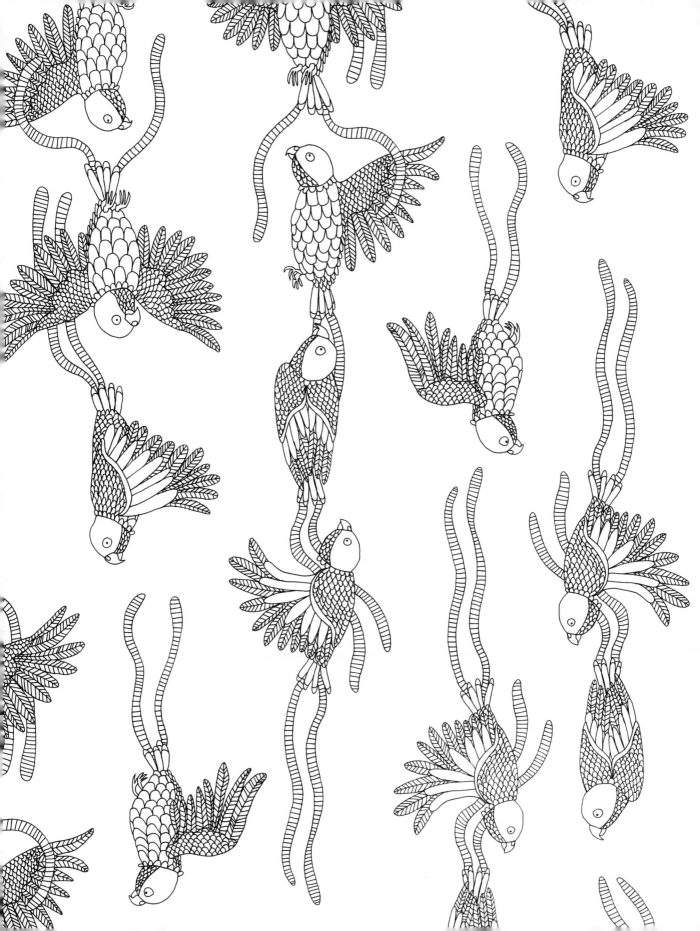

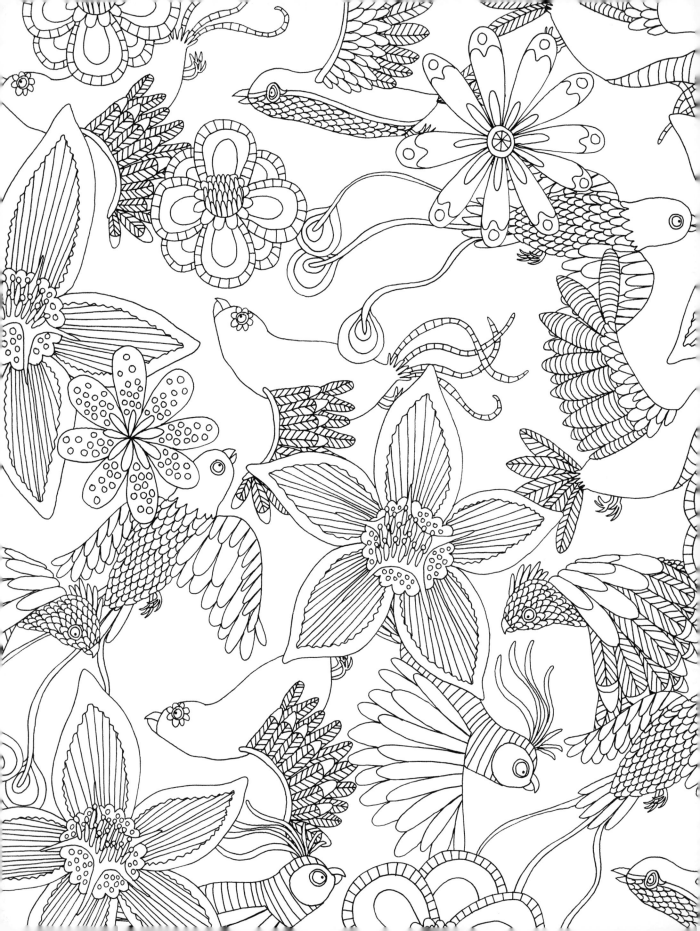

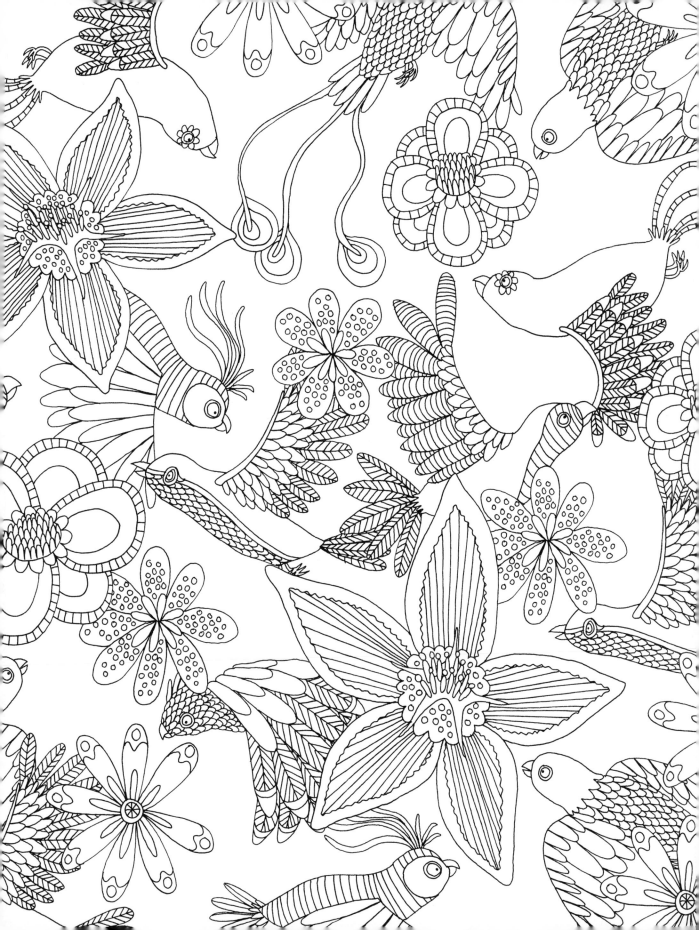

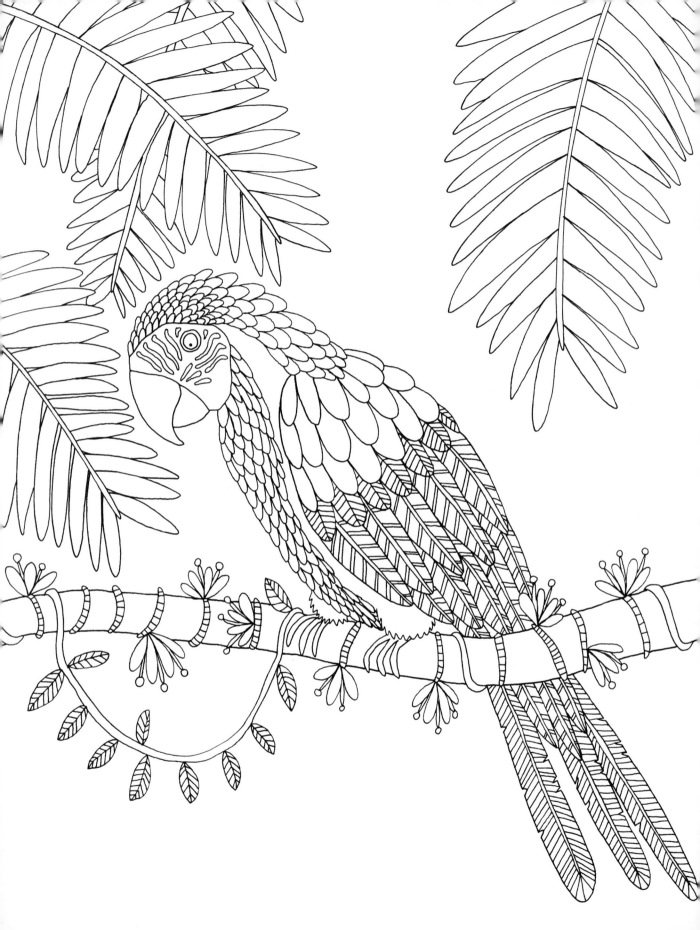

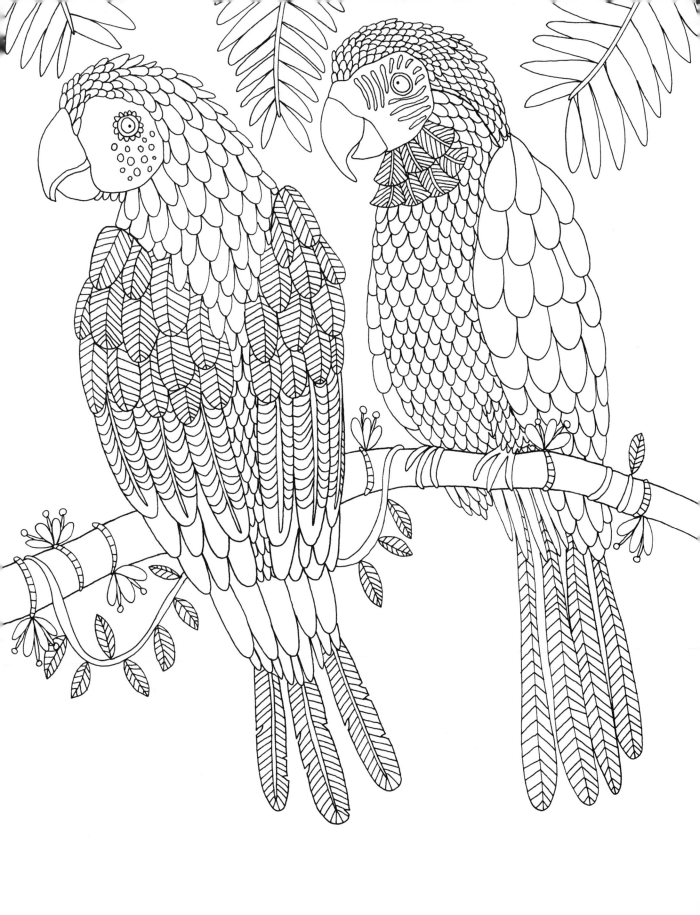

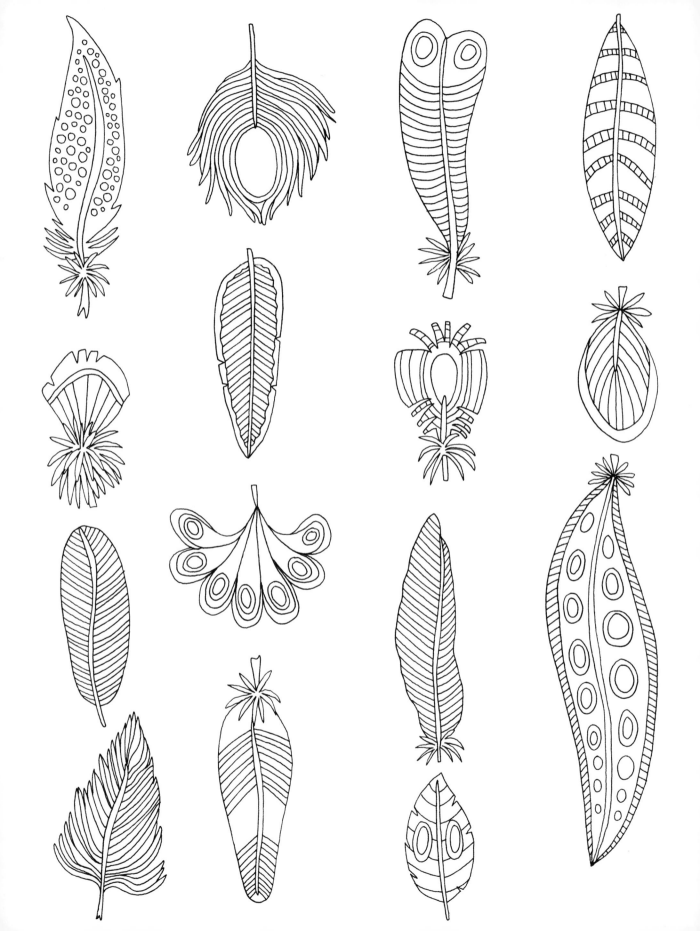

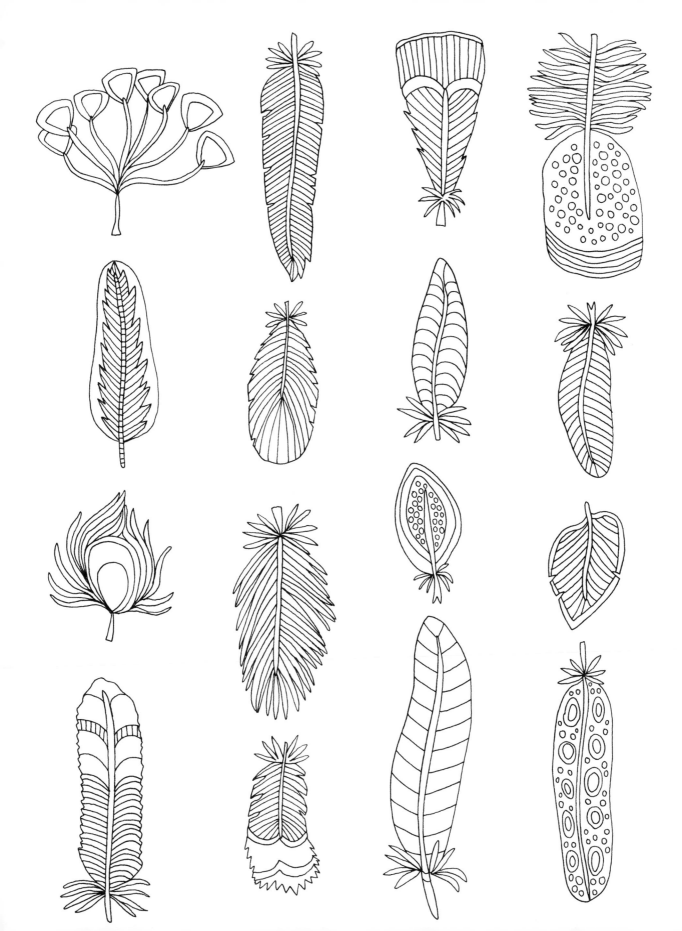

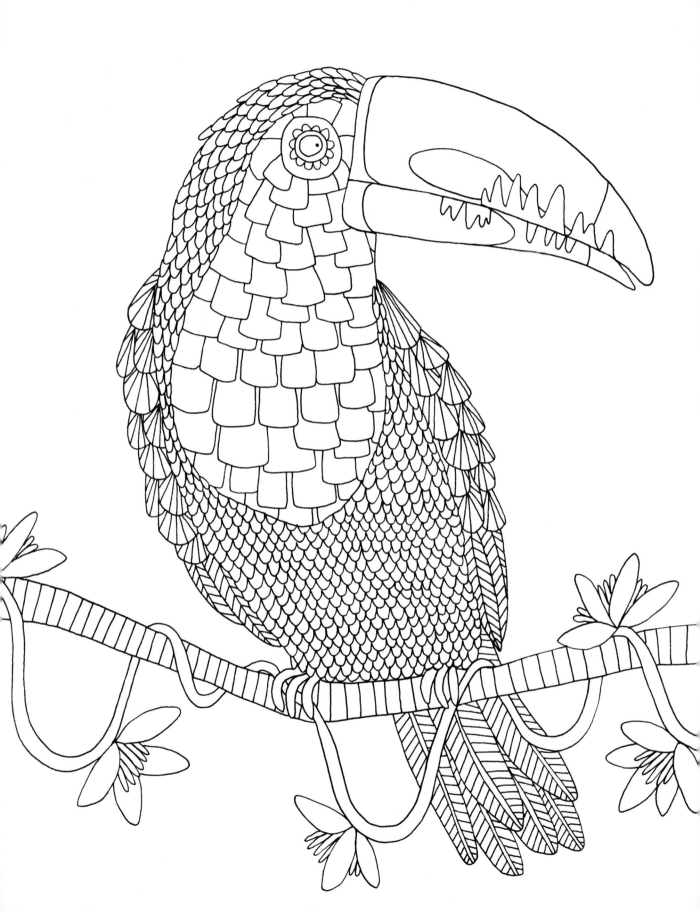

TOUCAN

Toucans use a network of blood vessels in their bill to regulate their temperature. The blood vessels expand to cool the toucan down in the same way that elephants use their ears.

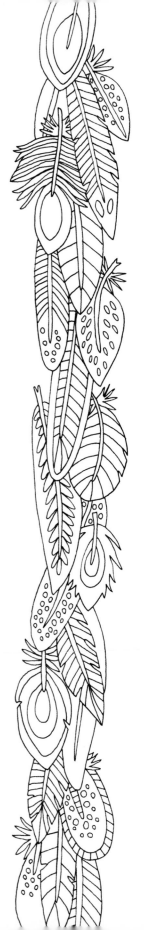

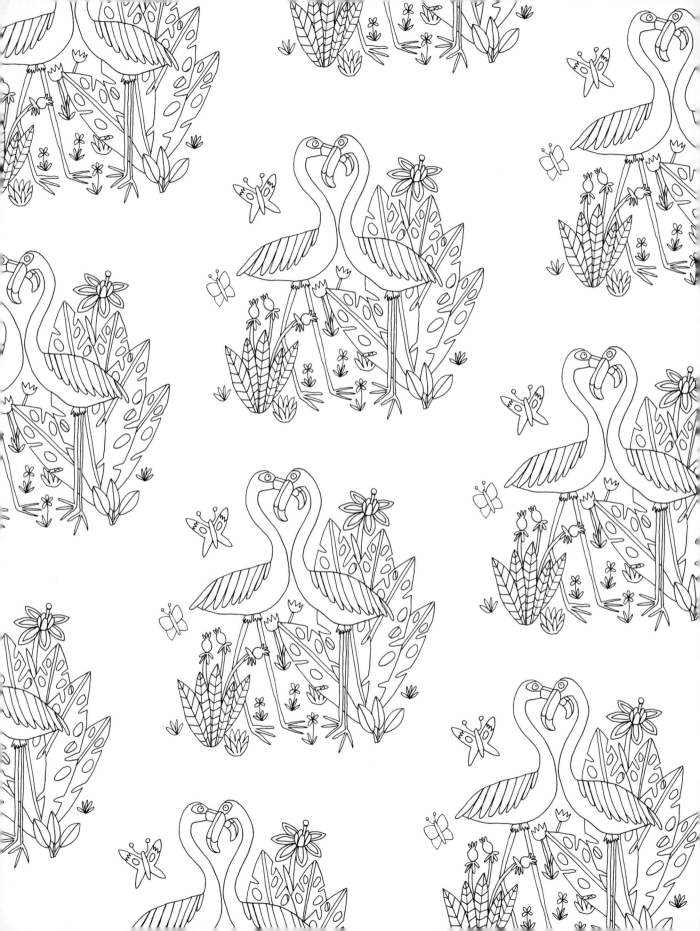

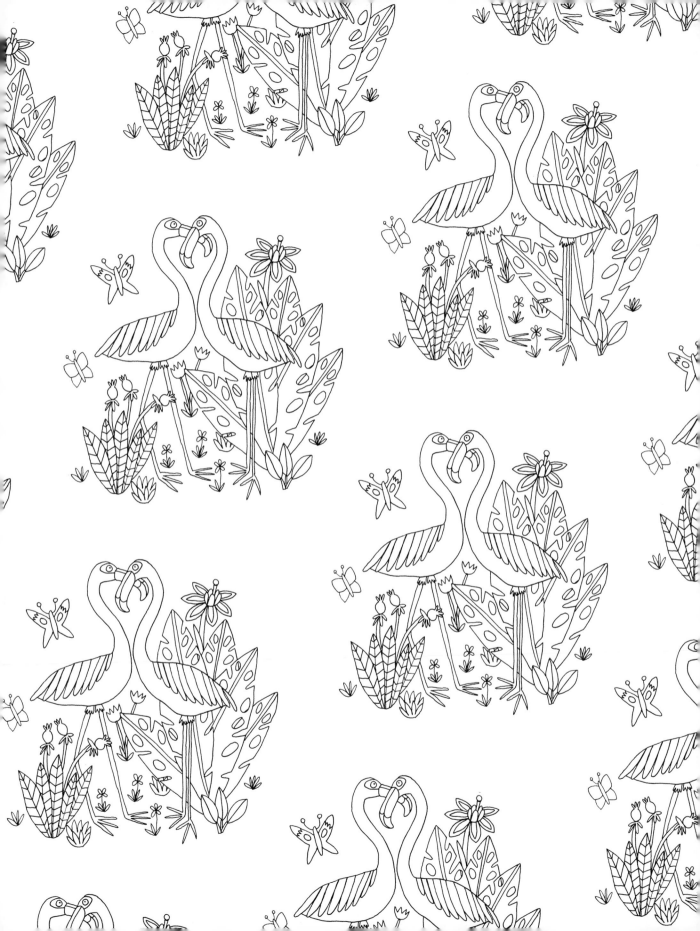

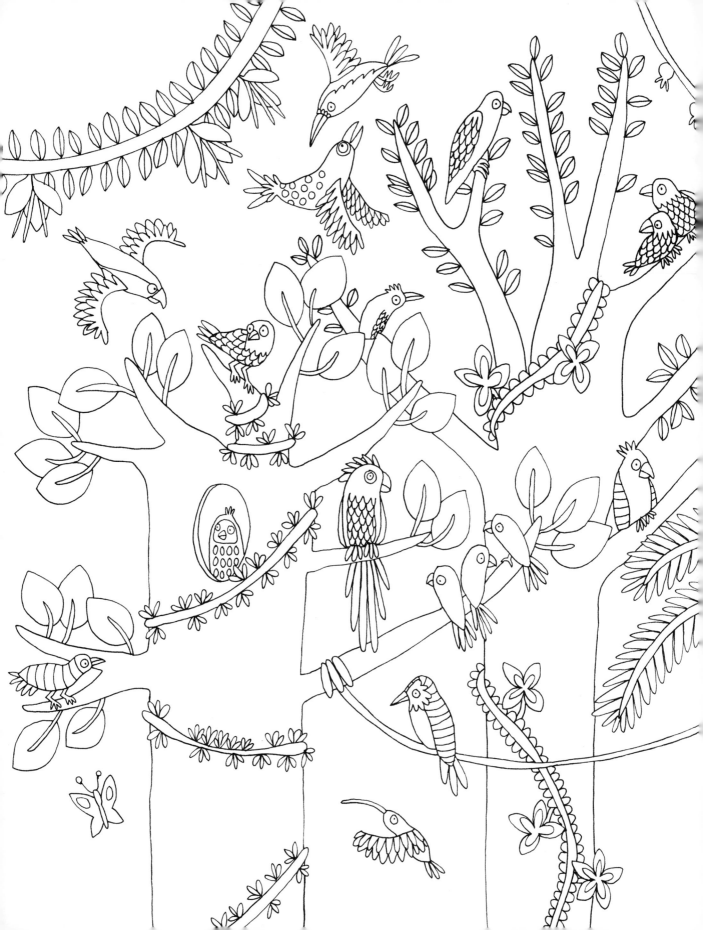

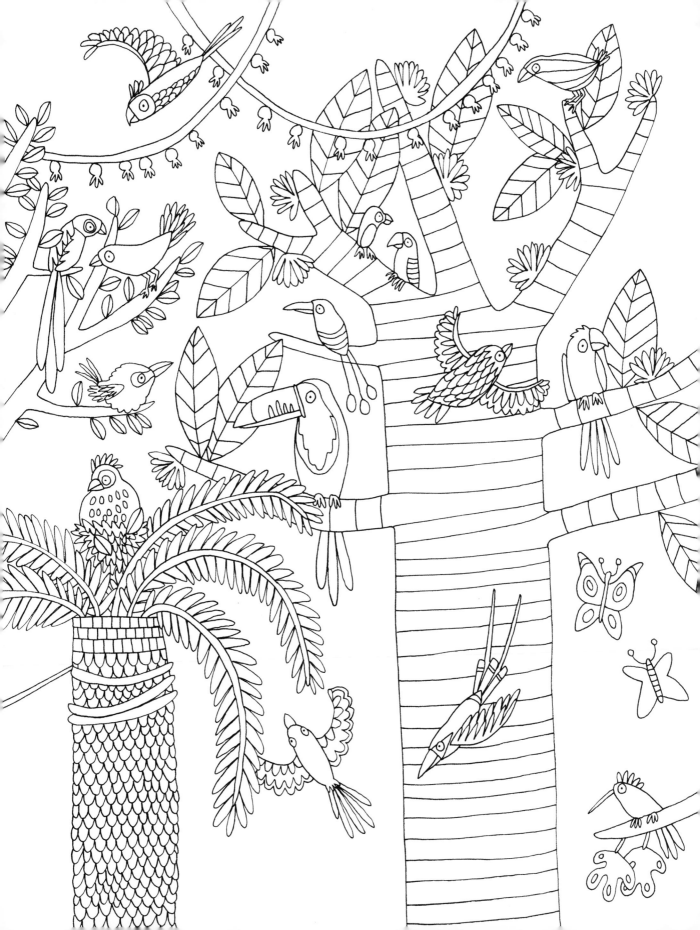

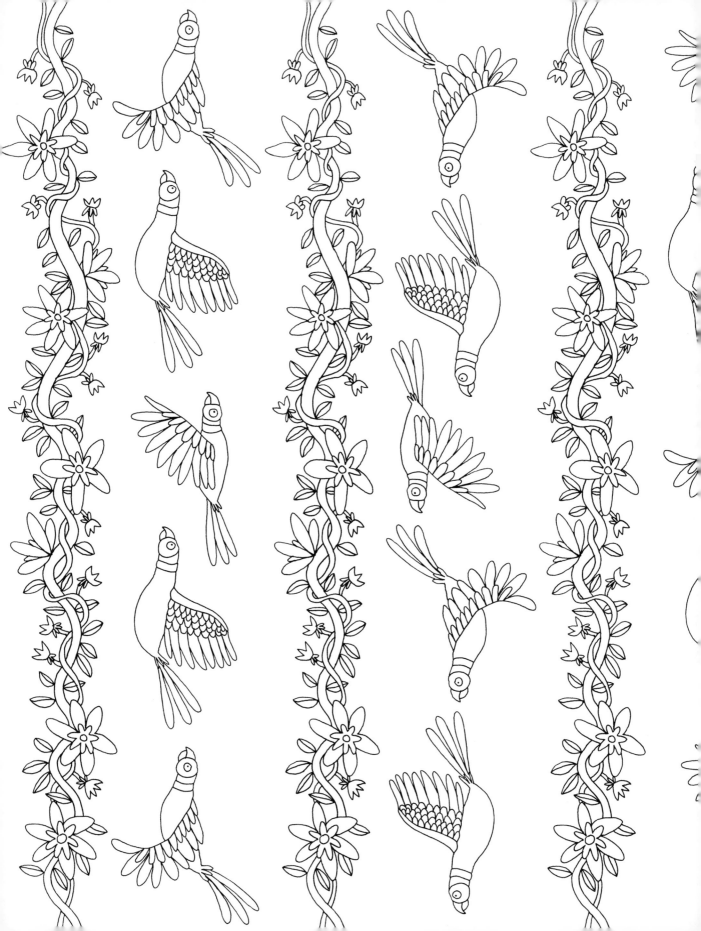

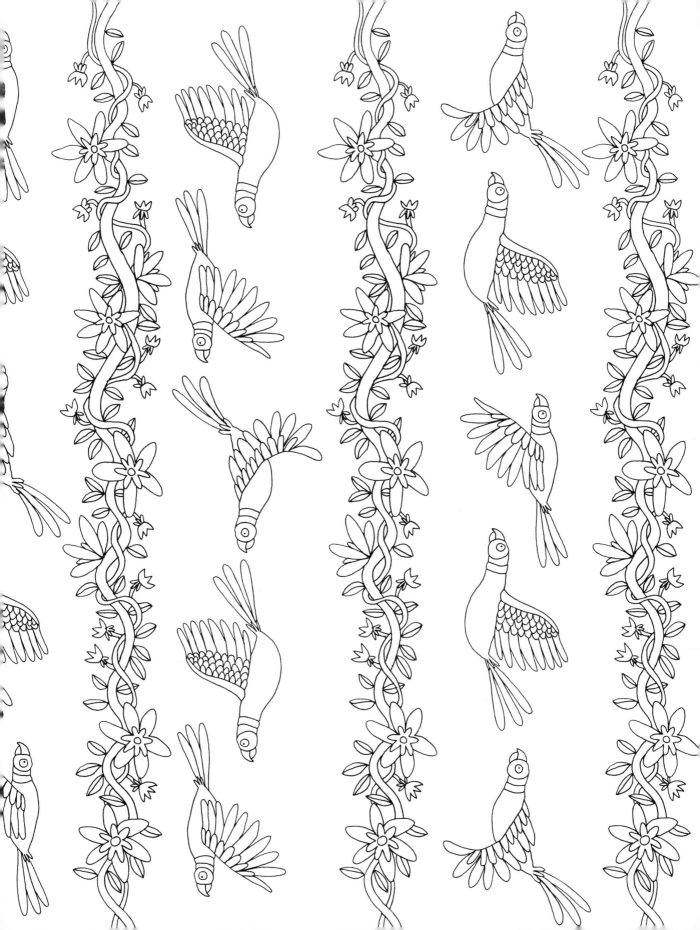

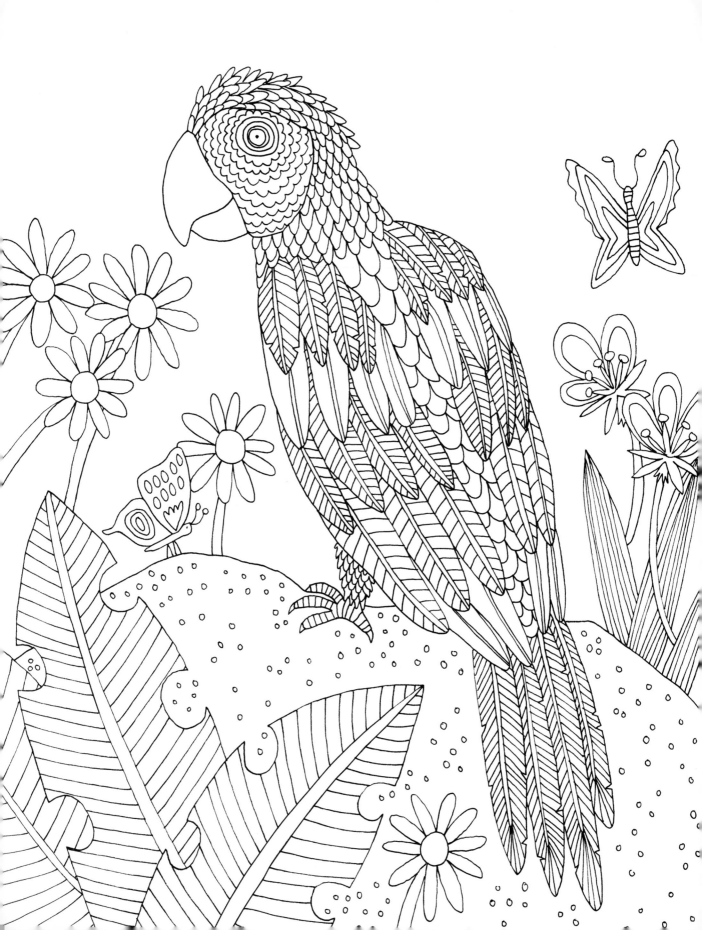

MACAW PARROT

Macaws have a bone
inside their tongue to
help them eat tough
fruit and nuts.

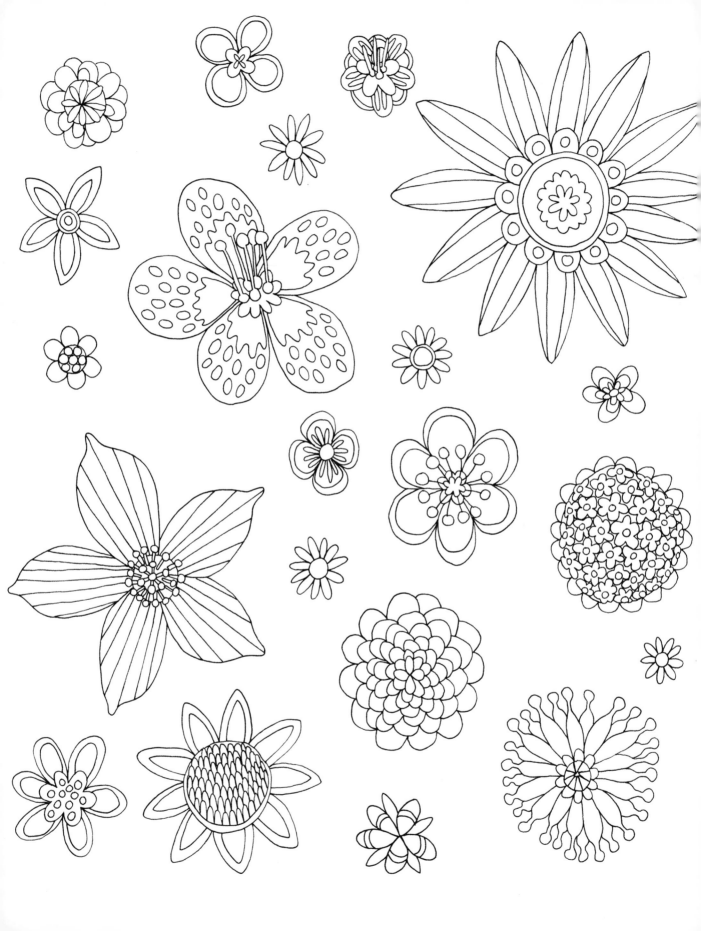

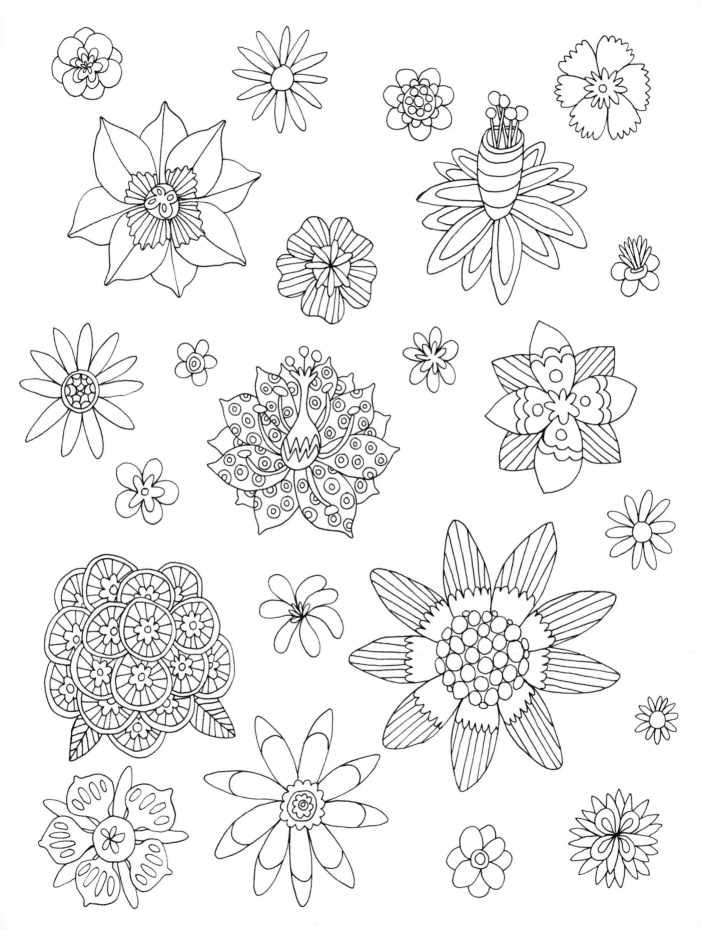

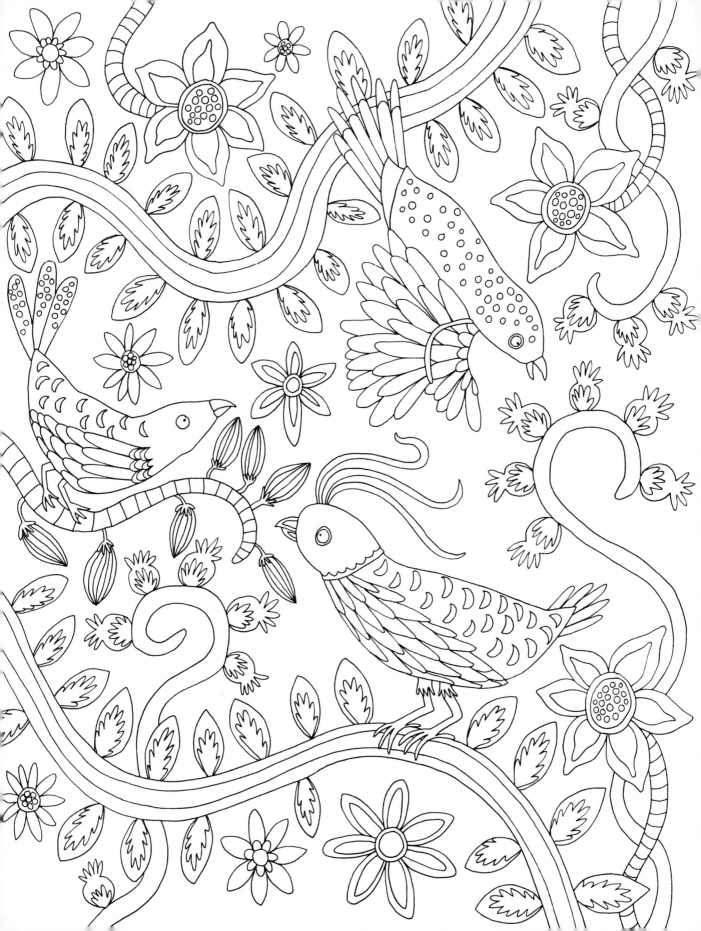

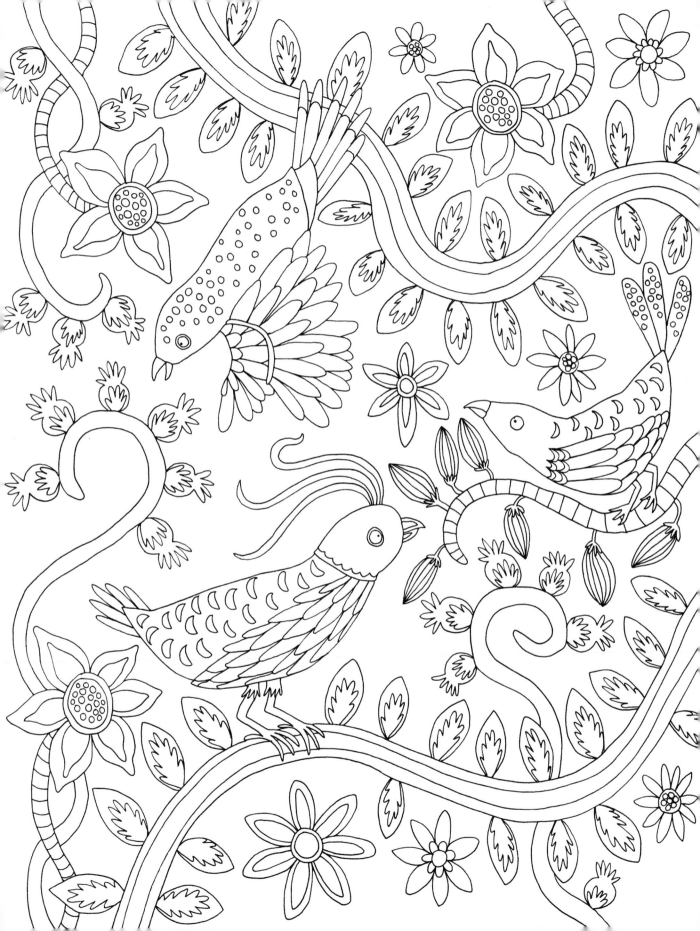

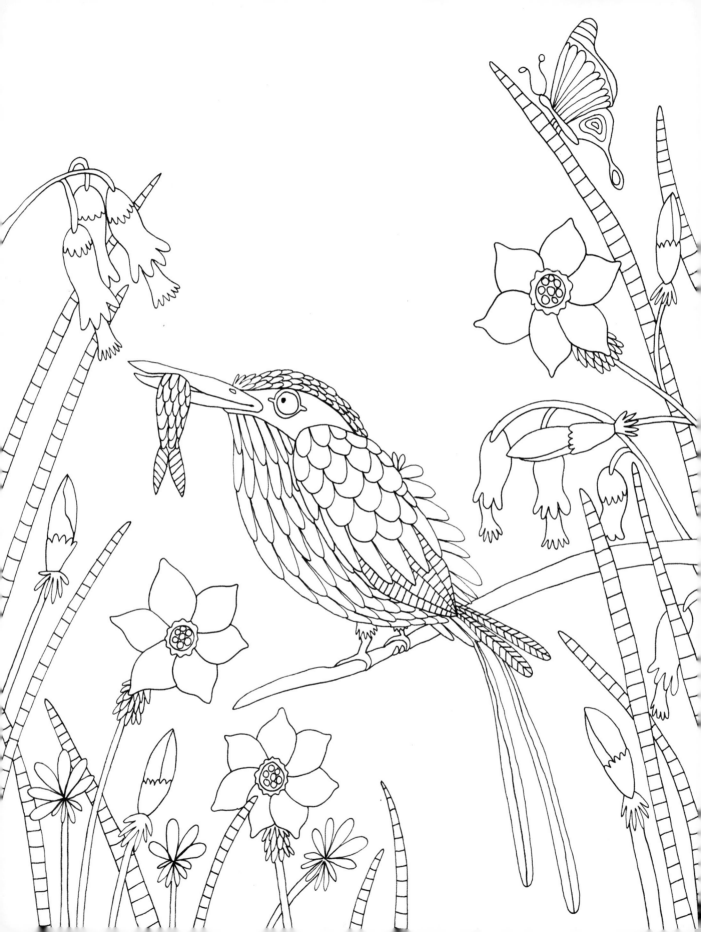

KINGFISHER

Kingfishers can't hunt with their eyes open. Their eyes are protected by a third eyelid which closes automatically as they dive down into the water for fish.

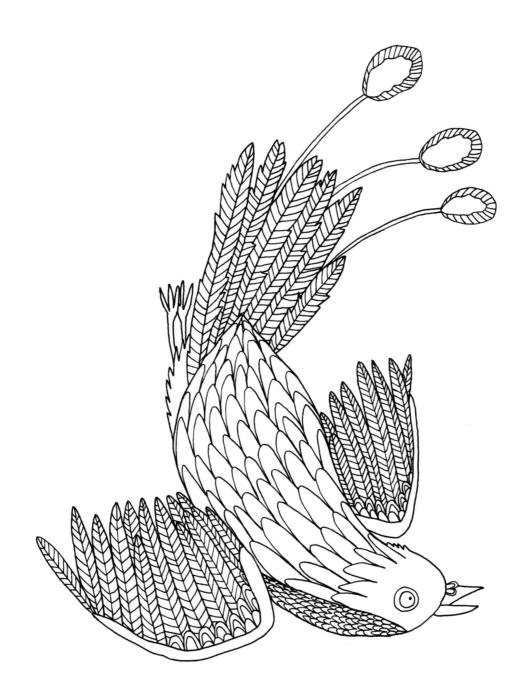

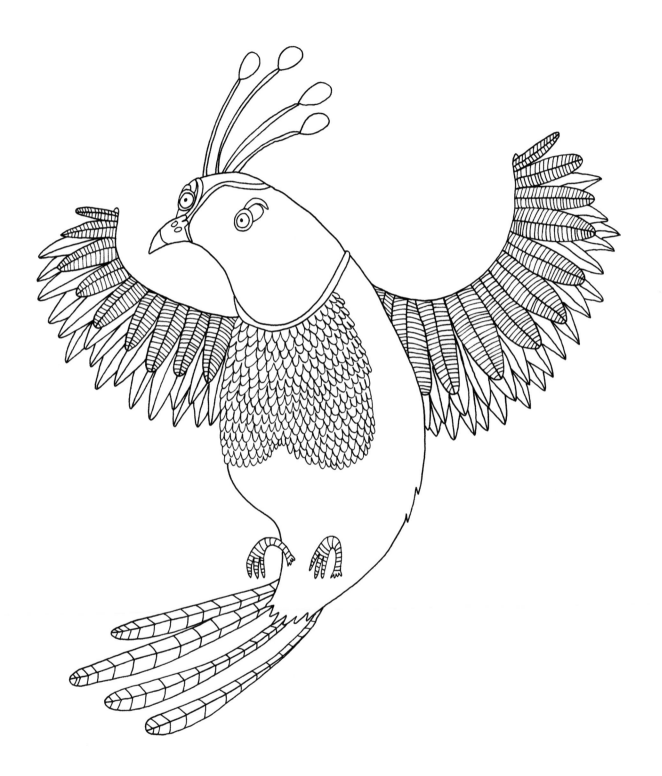

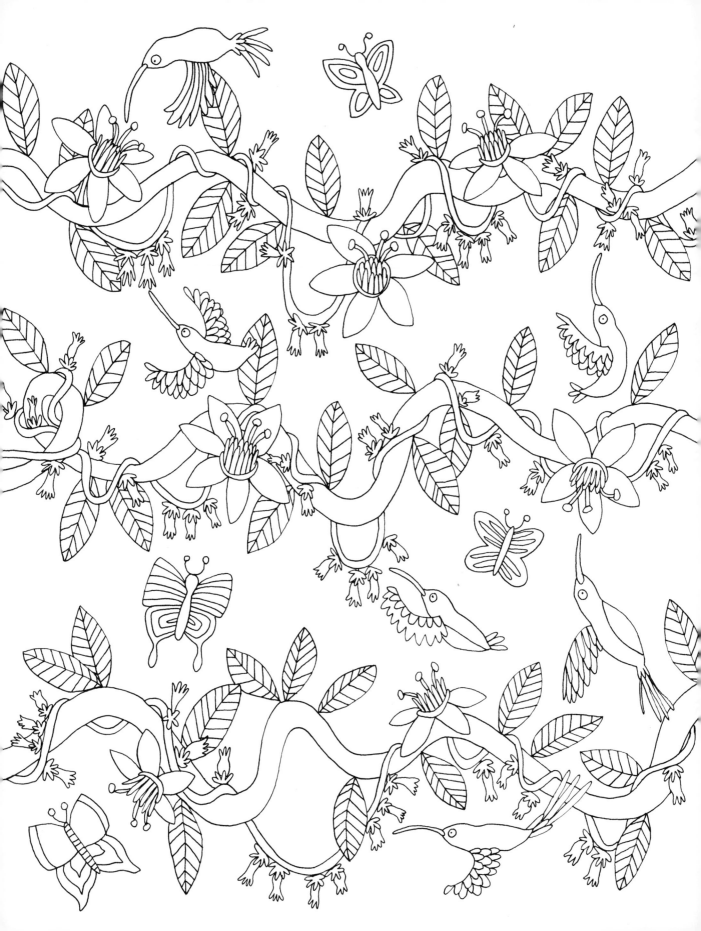

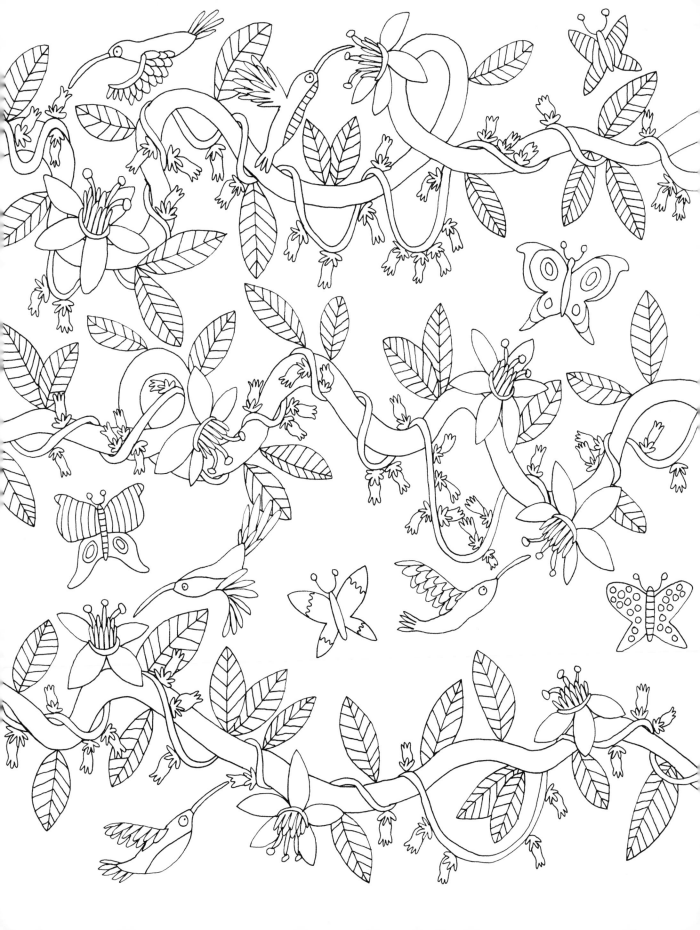

CARDINAL

The bird is named for the
male's red feathers and their
similarity to a Catholic
cardinal's red vestments.

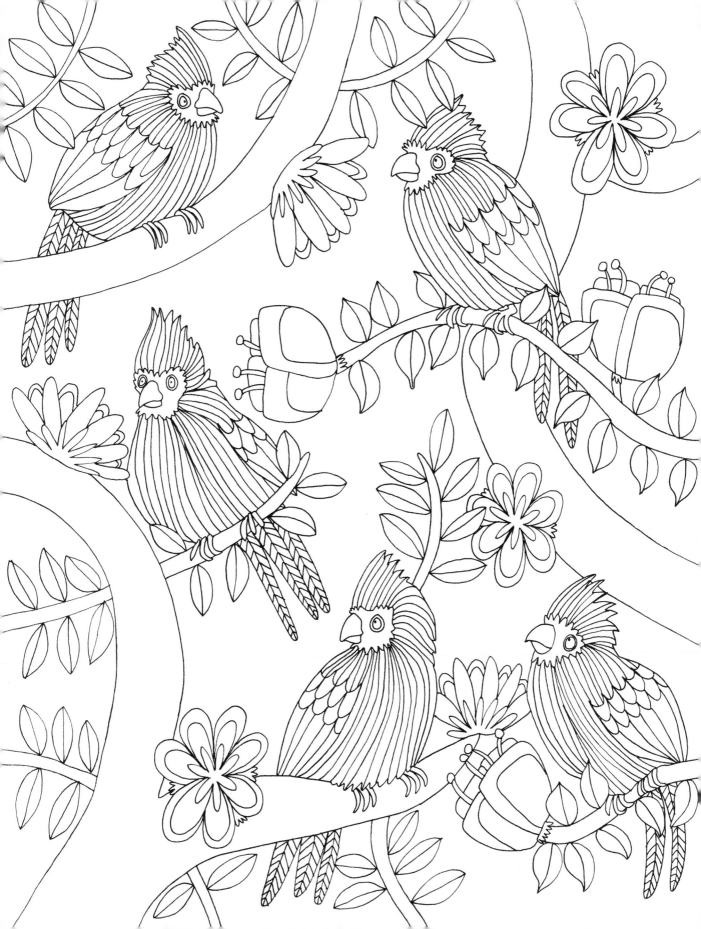

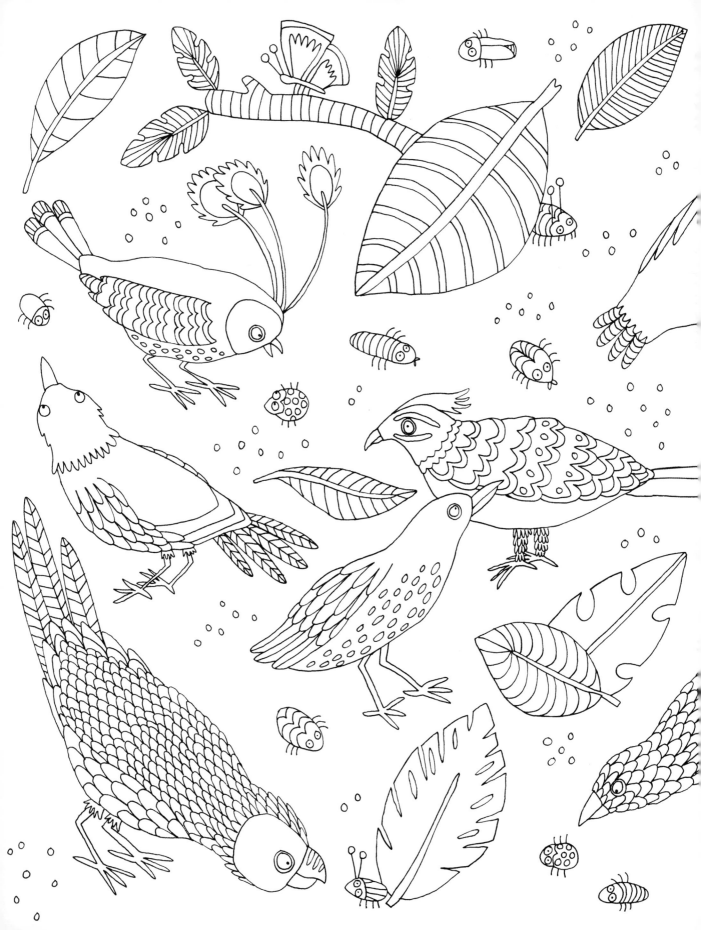

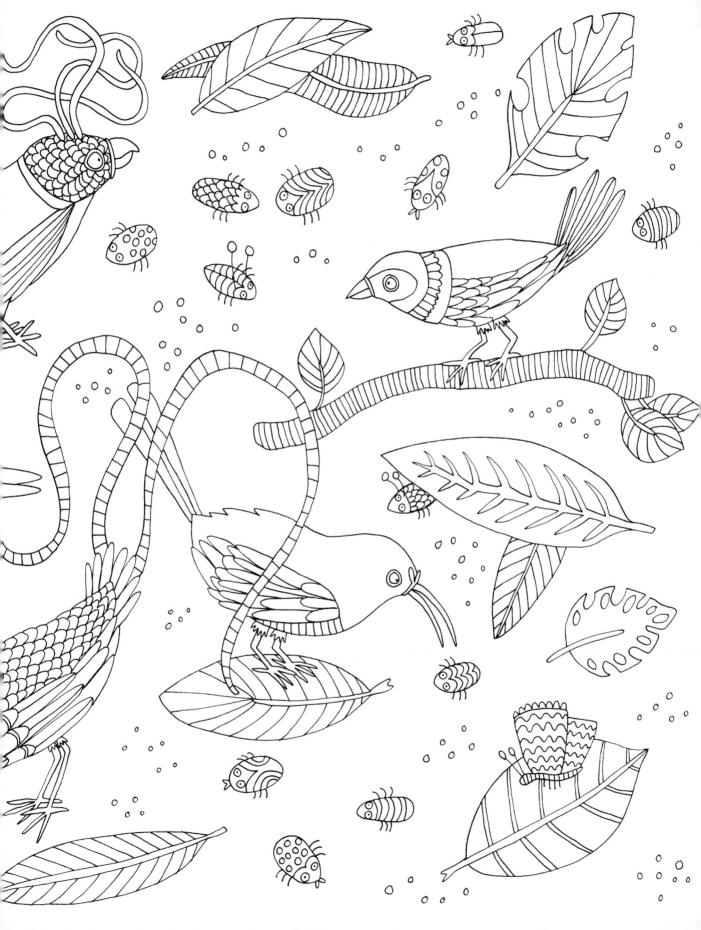

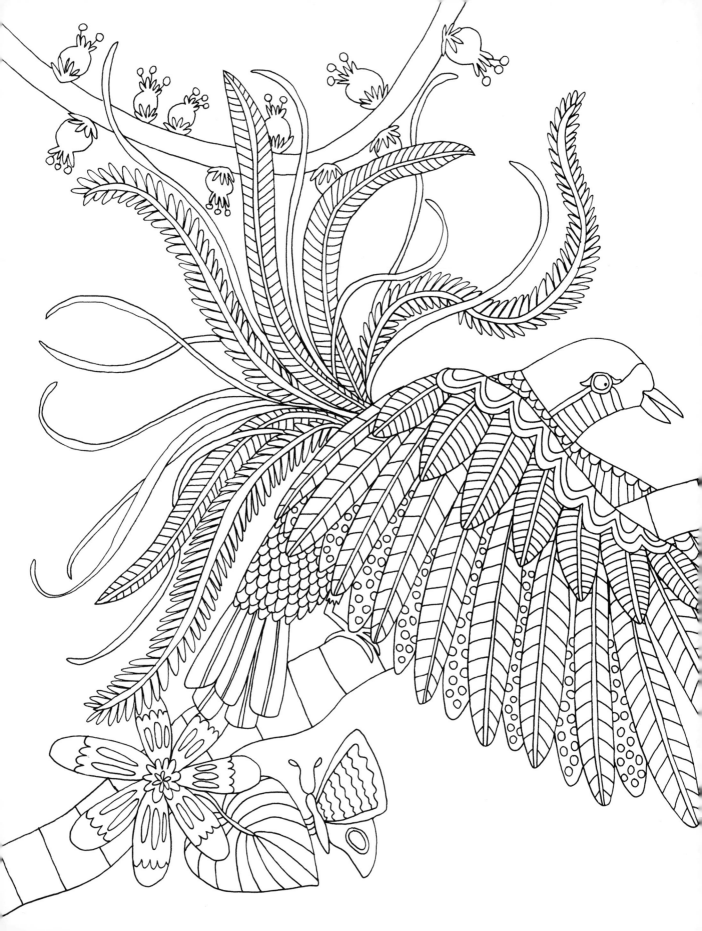

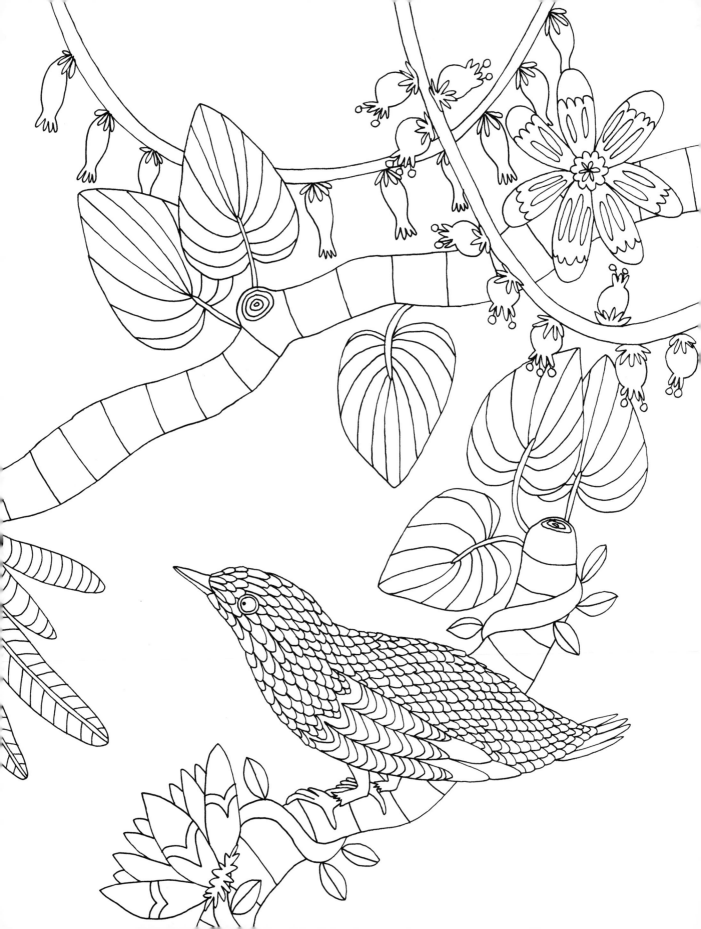

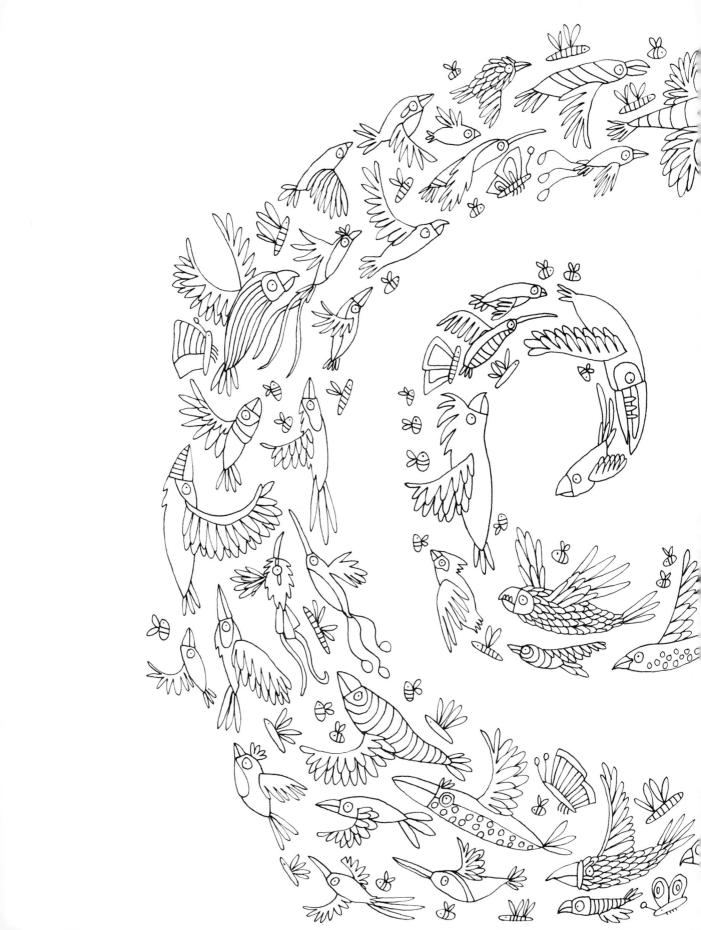

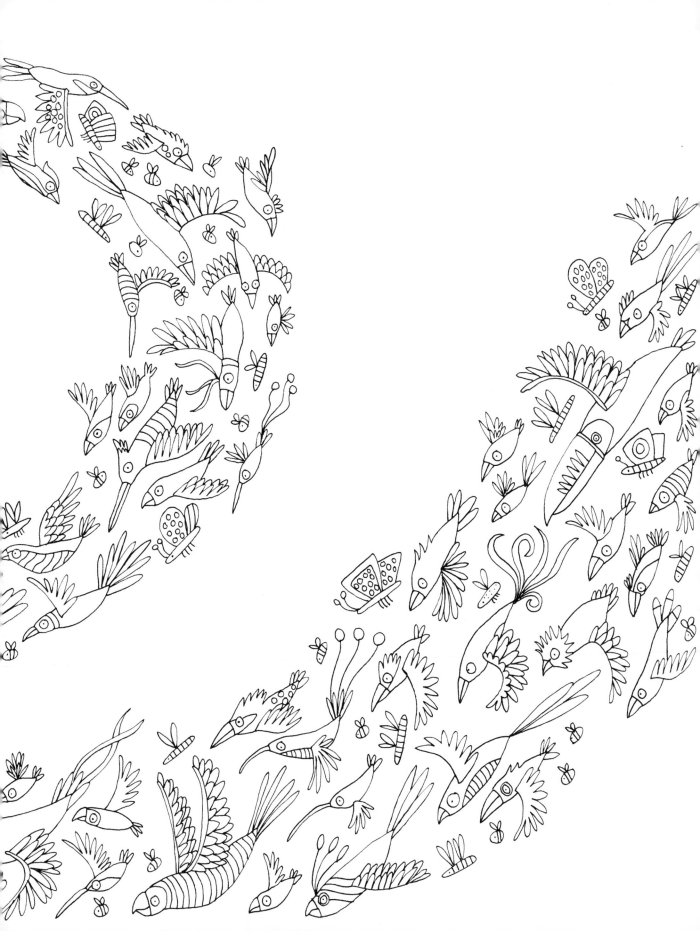

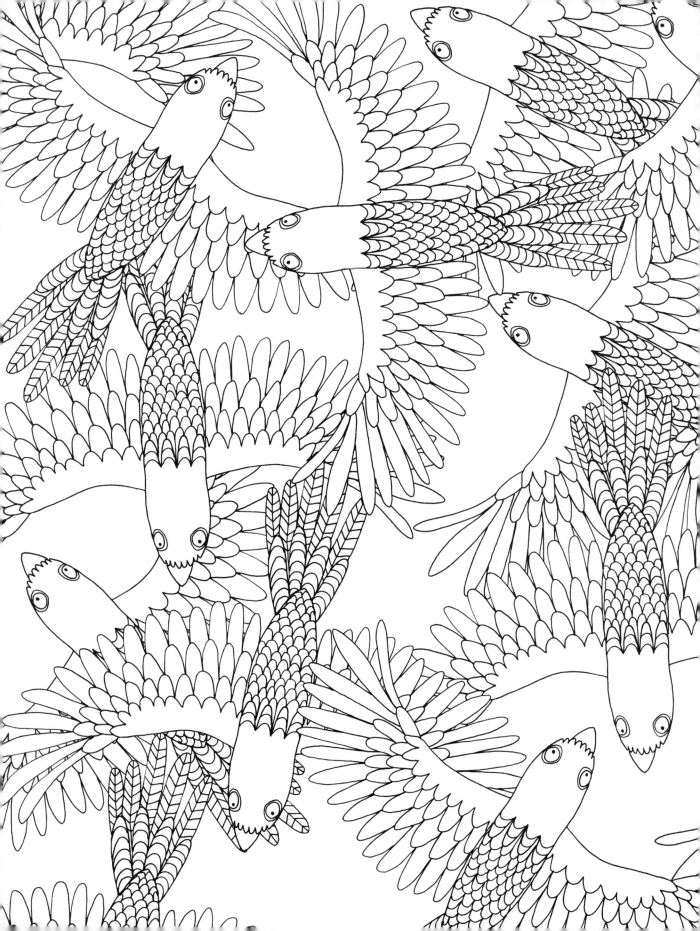

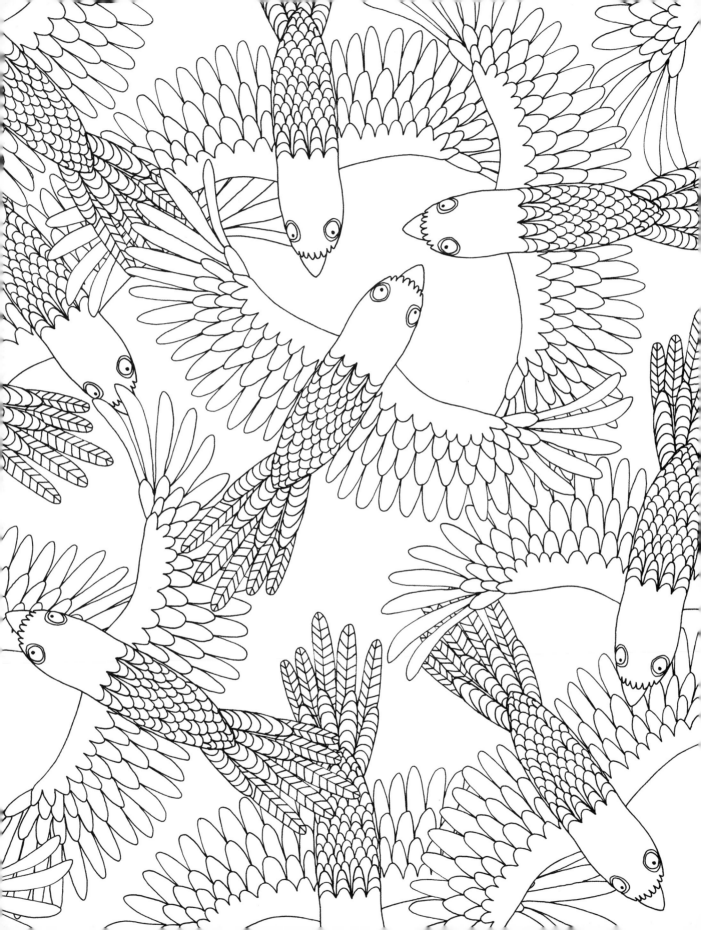

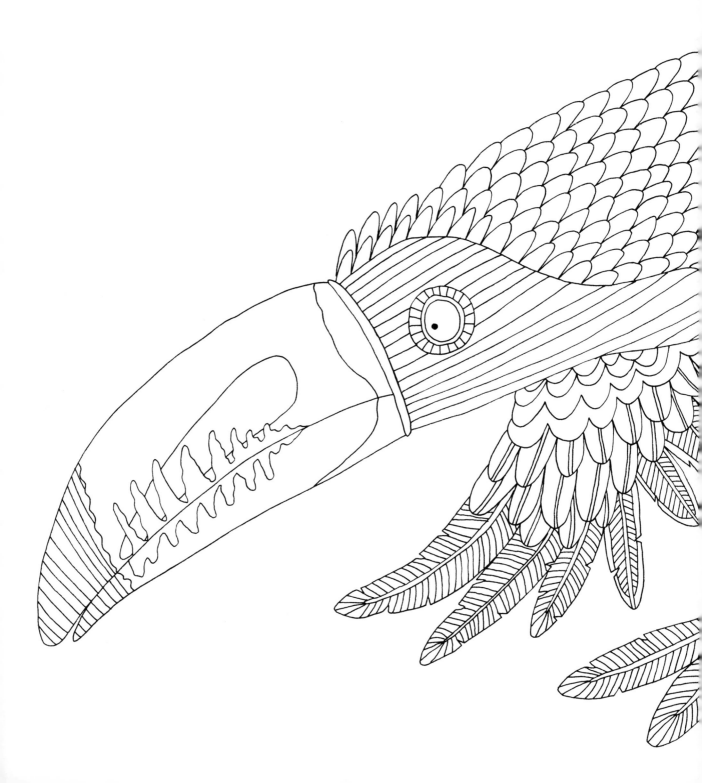

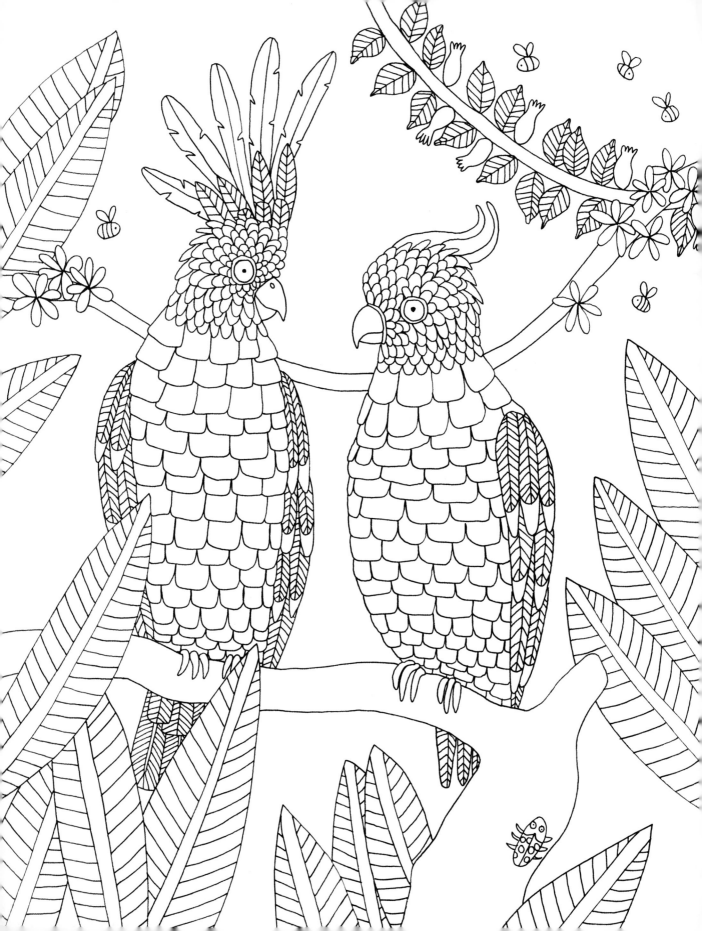

COCKATOO

A cockatoo's call
can be heard from
over a mile away.

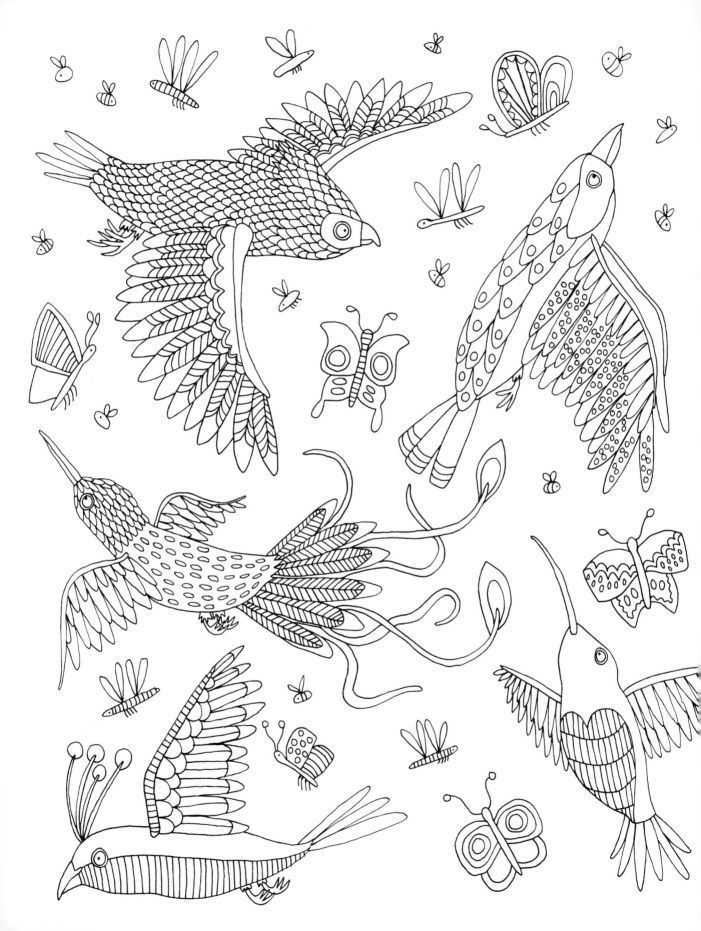

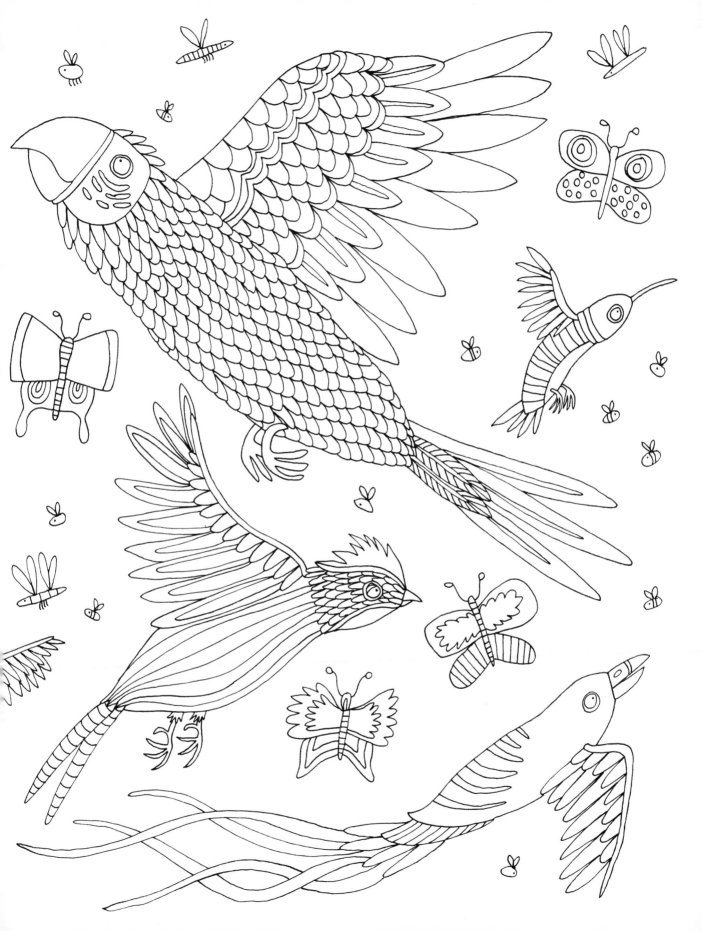

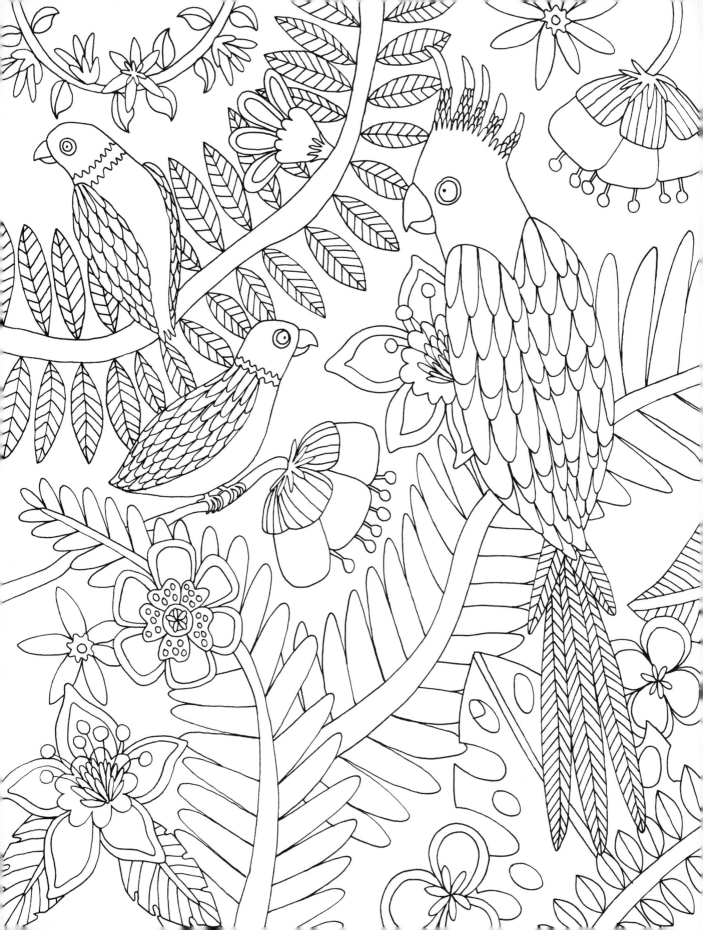

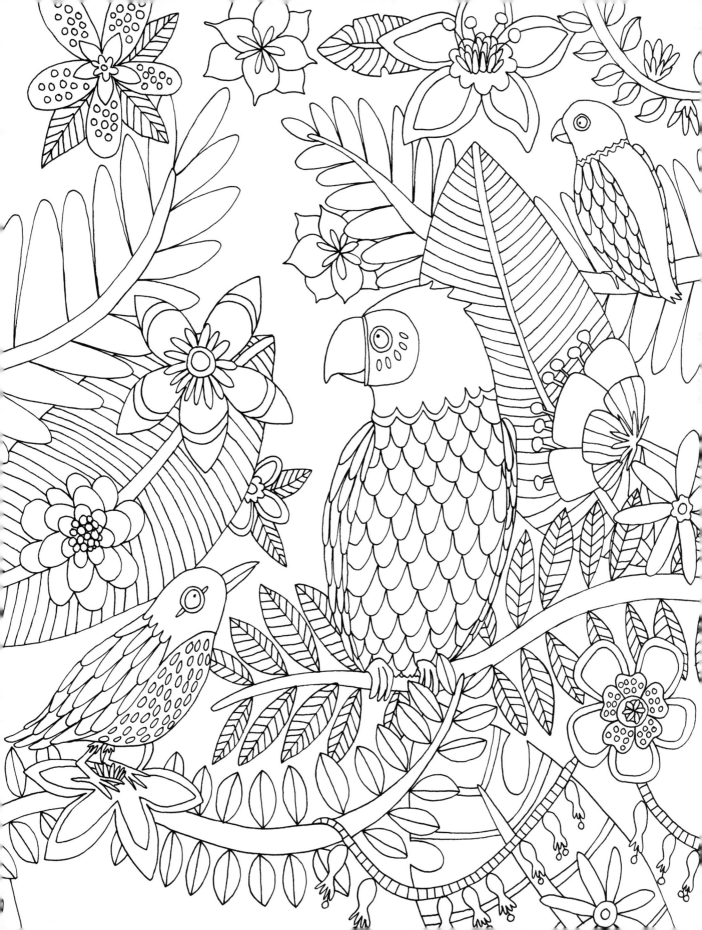

BLUE MAGPIE

The blue magpie can
mimic the calls of other
birds and animals.

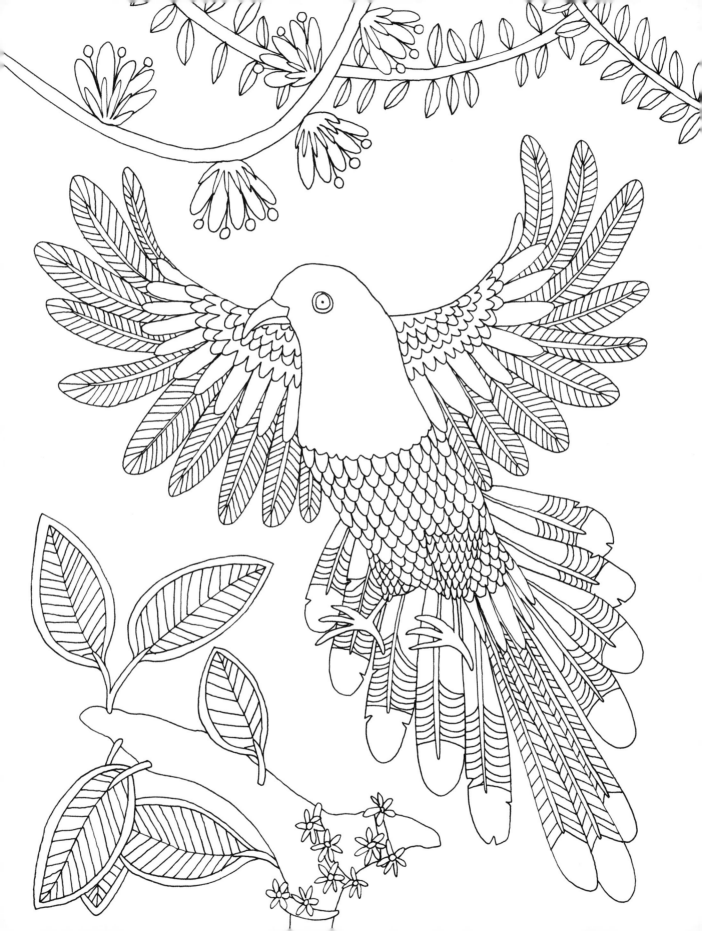

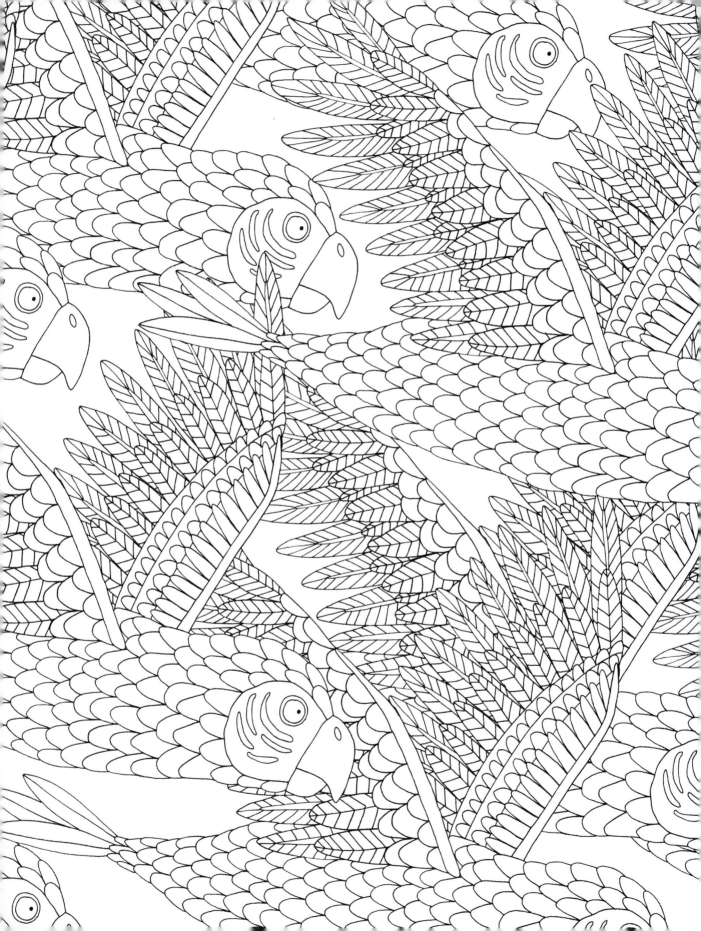

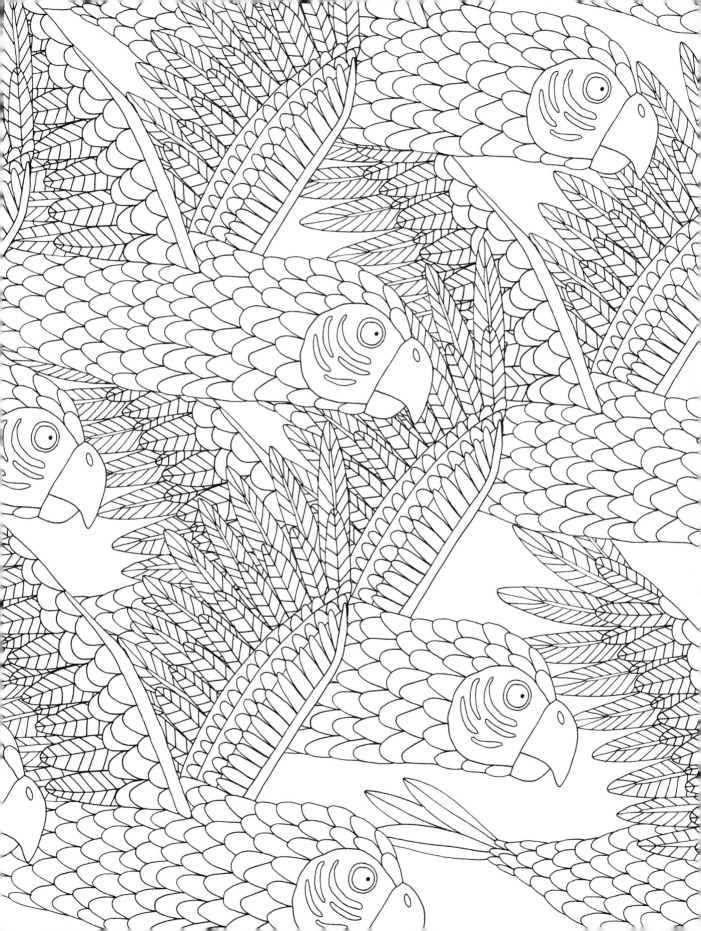

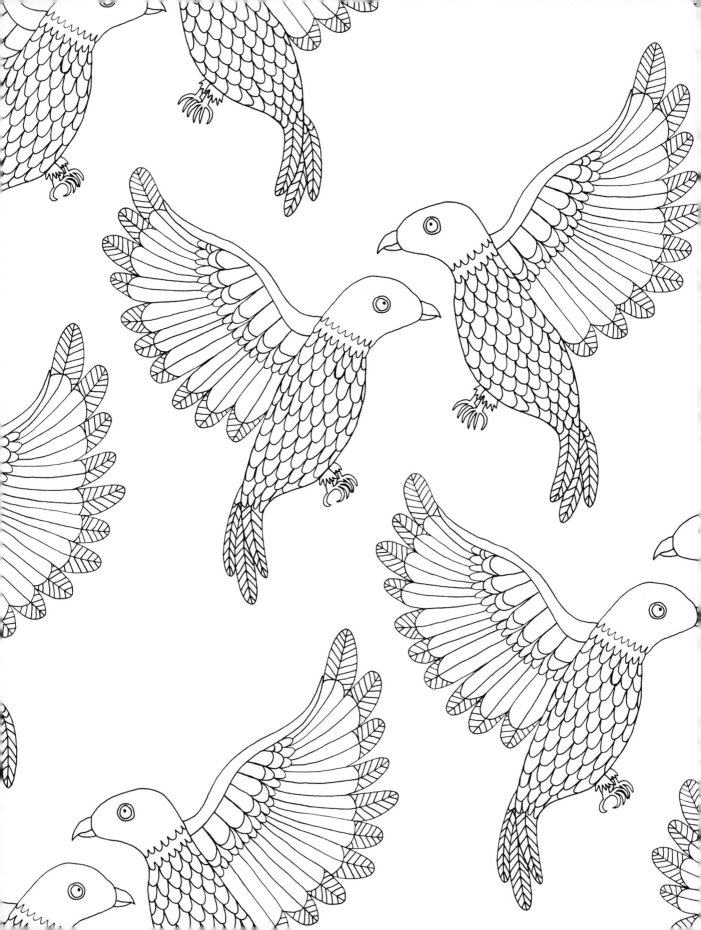

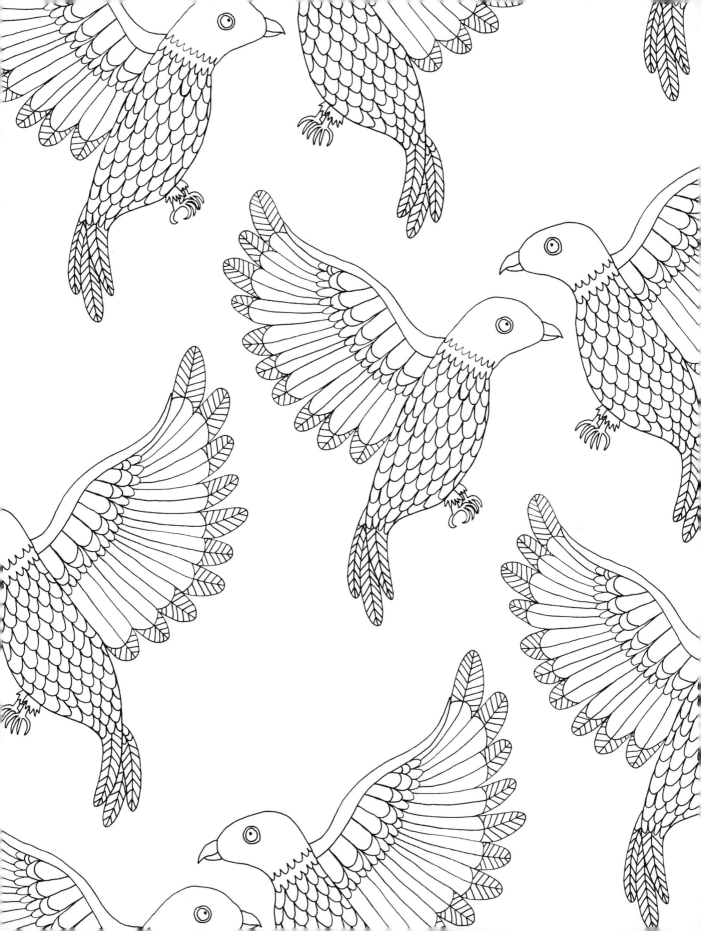

FLAMINGO

Flamingos can only
eat with their heads
upside down due to
the structure of
their bills.

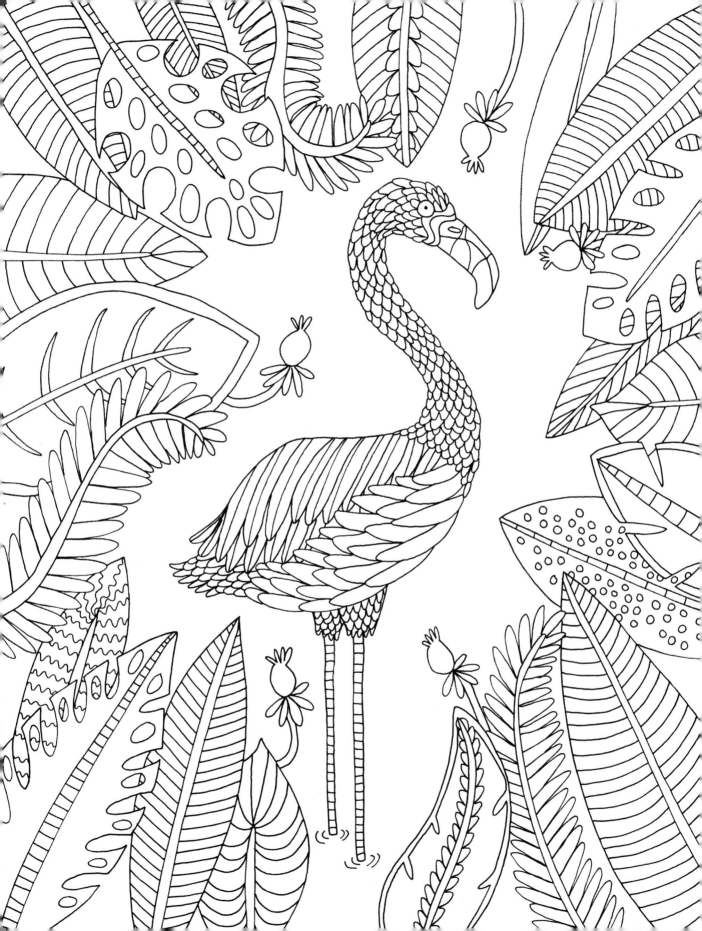

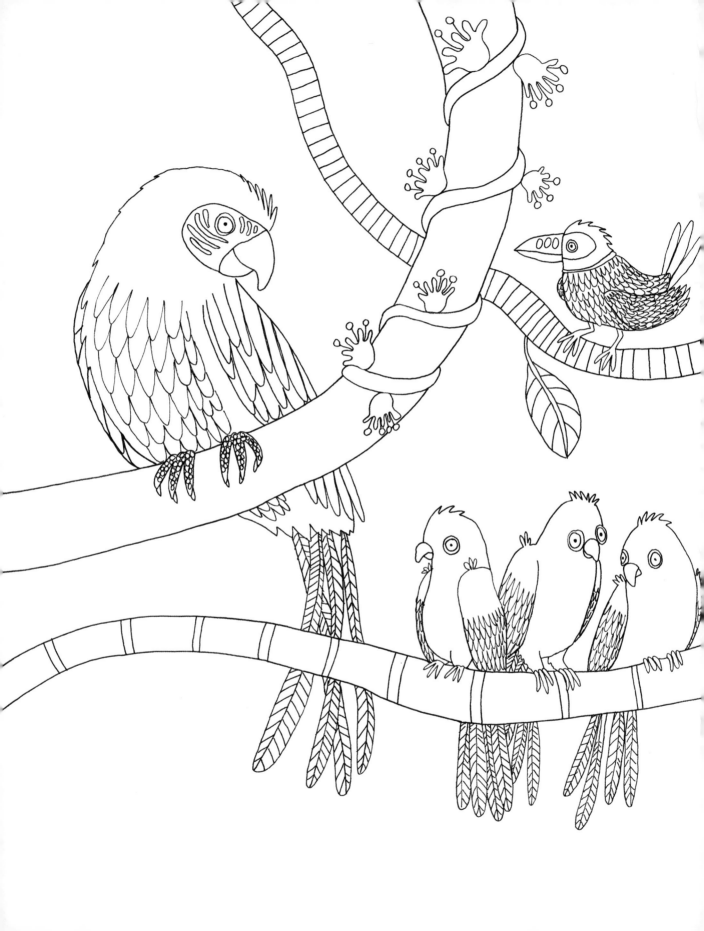

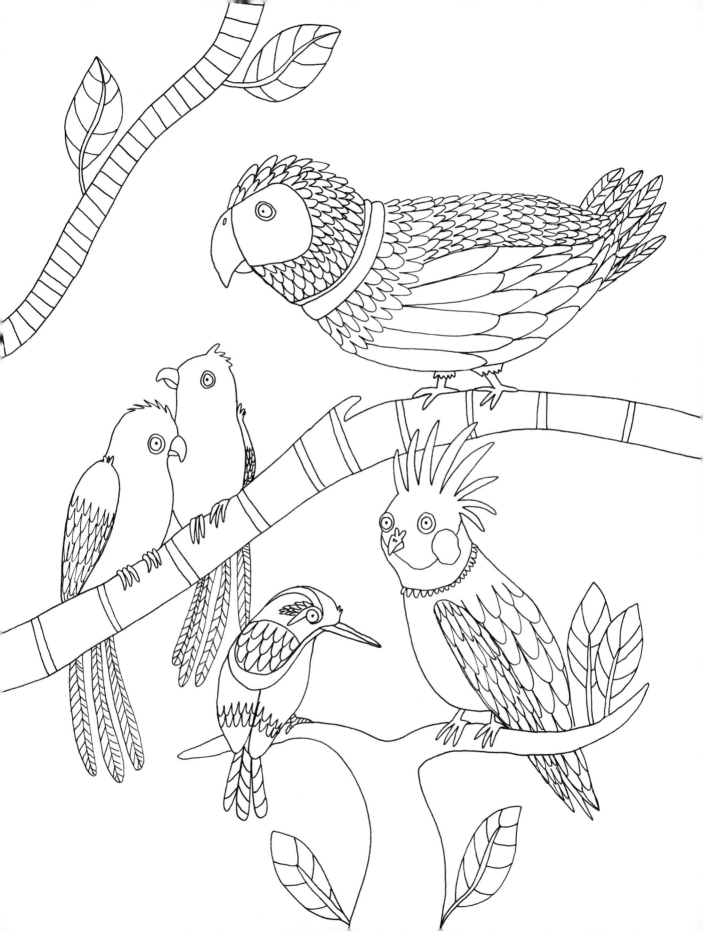

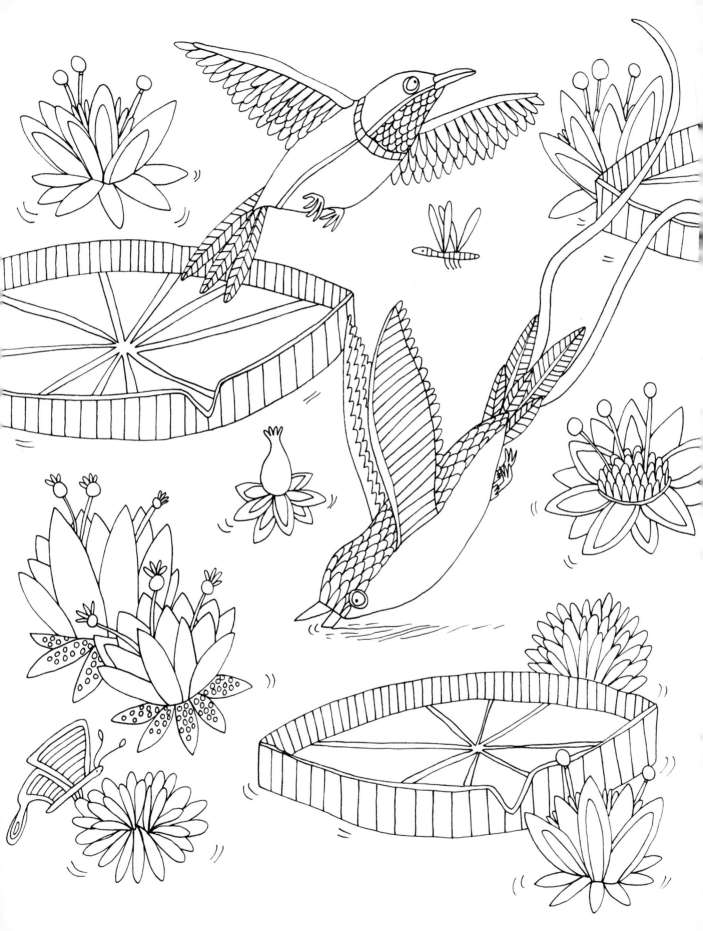

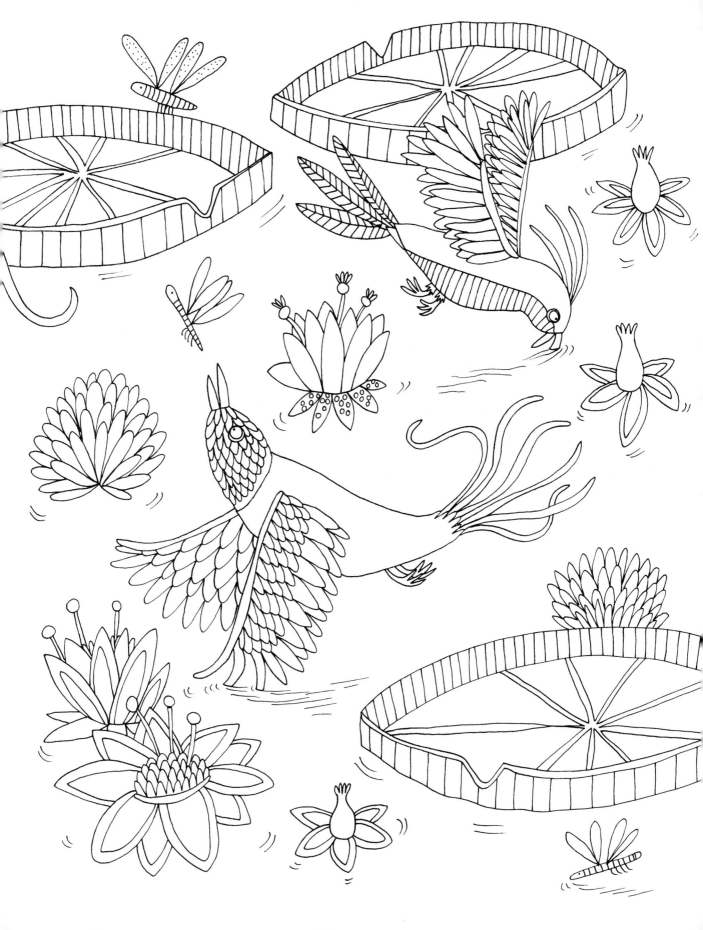

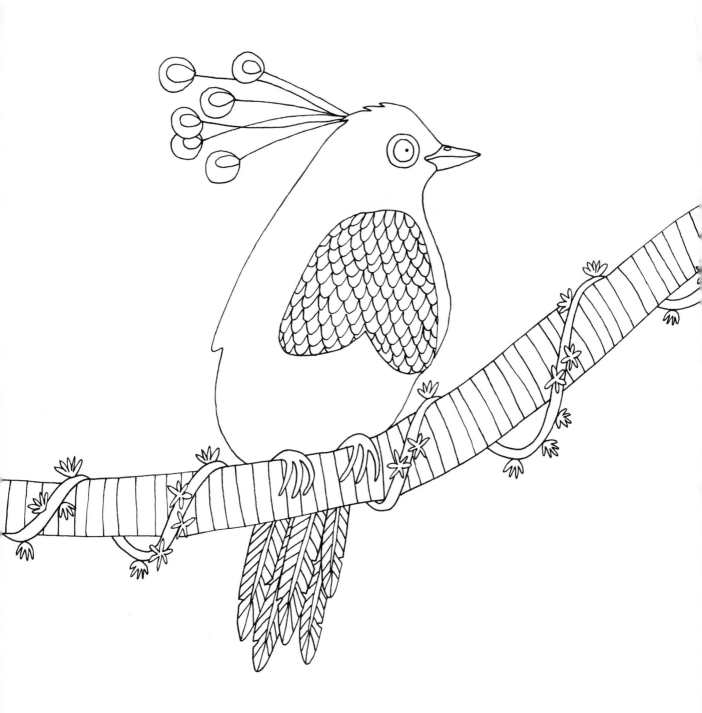

About me

I grew up in the deep dark depths of the English countryside – climbing
in trees and taking my rabbit for walks in the fields was how I would
spend my time. I am now an illustrator and designer based in London.

Growing up surrounded by nature has really influenced my illustrations.
My work almost always revolves around the natural world and animal
kingdom – I am totally obsessed with it! I have 42 potted succulents
and cacti and the space in which I work is becoming increasingly like
a jungle as my plant collection grows. I think soon I'm going to
start finding cacti growing out of my USB drive as it seems like every
available space is becoming inhabited by plant-life!

I illustrate my work by hand rather than digitally, as I enjoy the
spontaneity and also the 'happy mistakes' that can occur along the way.
I draw every day and take my sketchbook wherever I go in case I see
something particularly interesting. My favourite places to draw are
museums and botanical gardens as they're so relaxing;

If you'd like to keep up to date with my work,
I can be found online at @lornascobie.

www.lornascobie.com

Birds of Paradise by Lorna Scobie

First published in 2016 by Hardie Grant Books, an imprint of Hardie Grant Publishing
This revised edition released in 2020

Hardie Grant Books (UK)
52-54 Southwark Street
London SE1 1UN

Hardie Grant Books (Australia)
Ground Floor, Building 1
658 Church Street
Melbourne, VIC 3121

hardiegrant.co.uk

British Library Cataloguing-in-Publication Data. A catalogue record
for this book is available from the British Library.

ISBN: 978-1-78488-067-5

10 9 8 7 6 5 4 3

Publisher: Kate Pollard
Senior Editor: Kajal Mistry
Editorial Assistant: Hannah Roberts
Designer: MingoMingo.co.uk
Retoucher: Butterfly Creative Services
Color Reproduction by p2d

Printed and bound in Wales by Gomer Press Ltd.